CELEBRATE AMERICA

CELEBRATE AMERICA
19TH CENTURY PAINTINGS
FROM THE
MANOOGIAN COLLECTION

is made possible
through the generous support
of

THE DIXON GALLERY AND GARDENS'
BOARD OF TRUSTEES
ENDOWMENT FUND
LIFE MEMBER SOCIETY

and

THE HUGO DIXON FOUNDATION

CELEBRATE AMERICA

19ᵀᴴ CENTURY PAINTINGS
FROM THE MANOOGIAN COLLECTION

Edited by Nicolai Cikovsky, Jr.

With Essays by
Richard A. Manoogian and Richard R. Brettell

The Dixon Gallery and Gardens, Memphis, Tennessee

The Dixon Gallery and Gardens gratefully acknowledges the generous support of International Paper.

Published as a compliment to the exhibition
Celebrate America: 19th Century Paintings from The Manoogian Collection

February 7 – April 18, 1999
The Dixon Gallery and Gardens
Memphis, Tennessee

Organized by The Dixon Gallery and Gardens

Cover: Martin Johnson Heade, *Magnolias on a Blue Velvet Cloth,*
 c. 1885-1895 (cat. 25)

The publishers have generously given permission to use abridged texts from the
following copyrighted works: *From the Hudson River School to Impressionism: American
Paintings from the Manoogian Collection.* [exh. cat., The Detroit Institute of Arts]
(Detroit, 1997), *American Paintings from the Manoogian Collection.* [exh. cat.,
National Gallery of Art] (Washington, D.C., 1989) and *A Private View:
American Paintings from the Manoogian Collection.* [exh. cat., Yale University
Art Gallery] (New Haven, 1993).

Library of Congress Cataloging-in-Publication-Data
Celebrate America: 19th Century Paintings from the Manoogian Collection
 p. cm.
 Catalogue of an exhibition organized by and held at
 The Dixon Gallery and Gardens, February 7 – April 18, 1999
 ISBN 0-945064-02-0 (hc). – ISBN 0-945064-03-9 (pbk)
 I. Painting, American – Exhibitions. 2. Painting, Modern – 19th
 century – United States – Exhibitions. 3. Manoogian, Richard A. – Art
 Collections – Exhibitions. 4. Painting – Private collections – Michigan –
 Detroit – Exhibitions. I. Manoogian, Richard. II. The Dixon Gallery and
 Gardens.

CONTENTS

DIRECTOR'S FORWARD

In the more than twenty years he has been actively collecting American Art, Richard Manoogian has been driven by three impulses— a deep love of his country; the collector's delight in the search for and acquisition of valued objects; and a passion for particular works of art that supercedes any need to fill a gap or to tick off a prescribed list of "must haves." Together, these instincts have given his collection of American paintings a breadth and diversity that is unsurpassed and a personality that is distinctively his own. One of the most important and celebrated collections of American Art in the United States, the Manoogian Collection's focus on the 19th century draws attention to Mr. Manoogian's appreciation of the singularly important period in American history when the new nation saw extraordinary growth and expansion and wrenched from its European antecedents art that was decidedly "American."

Celebrate America: 19th Century Paintings from the Manoogian Collection brings to The Dixon Gallery and Gardens 49 works — landscapes, still-lifes, trompe-l'oeil paintings, genre and figure paintings, tonalist and impressionistic works and, finally, pieces from the first decades of the 20th century. These stunning works chronicle the development of American art and document the nation's search for a new American identity at the same time. With this exhibition, we have a unique opportunity to trace the emergence and evolution of "Americanness" through the works of such luminaries as Albert Bierstadt, William Merritt Chase, Frederick Edwin Church, Thomas Wilmer Dewing, Asher B. Durand, Thomas Eakins, Frederick Carl Frieseke, William Michael Harnett, Childe Hassam, Martin Johnson Heade, George Inness, John Singer Sargent, and by lesser-known artists as Otto Henry Bacher, Alfred Thompson Bricher, Francis Augustus Silva, Otto Stark, Irving Ramsey Wiles, and George Wright.

In his essay, the Dixon's Consulting Curator, Dr. Richard Brettell, exploits the breadth of the Manoogian Collection as he explores the issue of "American" art from a variety of different angles.

While it is certainly true that American artists sought to define themselves as American and to create art separate and distinct from European models, we find it is not enough. Defining what is "American" art becomes more complex as we consider works by American artists who worked in America; by American artists whose careers brought them back to Europe and who must, in some ways, be considered European artists; and by foreign artists who spent much of their productive years working in America.

It was Mr. Manoogian's appreciation of the unique character, diversity and quality of American art that built his wonderful collection. It is in that same spirit that I invite you to enjoy this selection of masterworks from the Manoogian Collection of American art.

James J. Kamm
Director

A CONVERSATION ON COLLECTING

Richard A. Manoogian

I began collecting seriously for several different reasons. In the early 1970s, I became a trustee of the Detroit Institute of Arts, and I was also appointed to the White House Preservation Committee and the Fine Arts Committee at the State Department. Since I was devoting time to the arts from a civic standpoint, I decided that I might as well get more personally involved, and began collecting. I'm sure that collecting also served as a diversion from my busy work schedule. My work regularly took me to New York and other major cities where I often had opportunities to take an hour or two to visit galleries or museums, which reinforced my interest in art.

Initially, I was interested in contemporary art. My first acquisitions included Pollock, Stella, Kline, and David Smith. I even bought two paintings at the original Scull auction in the early 1970s. Unfortunately, my home had limited wall space, which made collecting large contemporary paintings difficult. At that time, there were a number of collectors in the Detroit area who had a great love of nineteenth century American art. I think some of their excitement rubbed off on me, which started my collecting in that direction.

I really began putting the major part of my collection together in the late 1970s. It was then that Larry Curry joined me as curator. Larry had been a curator of American art at several museums and I had a great deal of confidence in his "eye" and judgment. Although we have not always agreed on every painting, our tastes are very similar and Larry's knowledge of the history of American art and his museum background have played a major role in building the collection.

My wife, Janie, has also had a major influence on my collecting. Her support and tolerance of all the time and energy that goes into collecting have been invaluable. She has a natural instinct for judging the quality of paintings and I have come to regret the few times I did not act upon her advice.

I started collecting abstract paintings because of my liking for color and form. However, I also love trompe l'oeil still lifes, several of which are included in the exhibition. I admire their precision and detail and the extra amount of work that an artist puts into a trompe l'oeil painting. Maybe that comes from my manufacturing background and the appreciation it fosters in the physical effort that goes into making a successful, quality product. I hope that the same appreciation for quality is reflected in all the paintings in the exhibition.

I have always admired the great nineteenth century landscapes because they were painted when our country was still young and growing. They expressed the uniqueness of America, as opposed to portraits, whose style might have been copied from other times and places. Another area I have always loved is genre because these paintings show American life as it was and as it has evolved. Although many collectors think genre is too pictorial, I find that it captures the essence of a way of life we would have otherwise had difficulty visualizing. I have also loved Impressionist works from my earliest days as a collector.

I'm often asked, if the house is burning down, which of your paintings would you grab? Forgetting value for the moment, it would be quite a few; I'd probably try to grab all of them. If I had to identify my personal favorites in the collection I would probably end up identifying twenty, thirty, or forty pictures.

My collection is probably broader and much larger than most American private collections. I don't know if that's good or bad or just an obsession. It depends on your viewpoint. In retrospect, I think there are areas in which I might have been more selective, but a lot of that was a learning process. Sometimes one grows to love a painting whether or not it is the best work by that artist. The reasons for loving it may have to do with the painting itself, or what went into acquiring it. Every collection goes through a pruning process, but looking back, I regret letting go of only a few pictures. That's one of the advantages of having a large collection.

Some collectors know exactly what they are looking for—a Bierstadt of 1860 or 1862, or whatever it might be—and there's nothing wrong with that. Other collectors just love certain things, regardless of the year, or the period, or the artist. If they love it, they want it in their collection. I probably fall somewhere between

these two types of collectors. I am trying to build a comprehensive collection, but for me passion probably plays a bigger role than seeking out particular artists and periods. Anyway, I'm not sure in collecting you can pick exactly what you want. The passion of collecting is simply restricted by what is available.

One of the most frustrating aspects of collecting is trying to cover certain areas that are relatively rare. One would love to have important works by major artists—Homer, Whistler, or Eakins but very few are available. The search goes on, of course, but the facts are that only so many paintings exist, and many are already in other permanent collections. I have never collected with the idea of having something by everyone or of being encyclopedic. I have found it very enjoyable to locate a terrific painting by a lesser-known artist—a work of high quality by somebody of whom no one ever heard or really appreciated. I love to find a hidden treasure by an unknown artist or an unusual work by a well-known artist that would surprise most people. I think that is as exciting, or more exciting, than finding major works by more recognized artists.

It is also a challenge to find paintings that are dirty or in need of restoration and to try to visualize how they might look when cleaned and restored and reframed. Such works may have been overlooked by others, and yet turn out to be wonderful works of art.

In short, for me nothing surpasses the search and intrigue of collecting. I think all collectors get special satisfaction from locating objects that are difficult to find.

My greatest regret has been not paying a little bit more for something that was just wonderful, or taking the advice of experts who said something was not important enough to be in the collection even though my heart told me otherwise. Listening to your own feelings can lead you into trouble once in a while, but as long as you enjoy something, even if other people don't agree, you are still getting satisfaction out of owning it. It is surprising that if you really love something you tend not to change your opinion about it. On the other hand, if you are talked into acquiring something because it is important, you will often decide later that it is not something you are really all that excited about. If a collector really loves something at first sight, that reaction tends not to go away. The missing of the object that aroused that feeling may be a painful thing he has to live with all of his life.

It is crucial for a collector to become knowledgeable enough to be able to make his own judgments. When a collector cannot learn everything he needs to know, he should seek out the best information and guidance available. He must be free to make his own choices, and sometimes to disregard the advice he has been given. For example, you may have been told that this is not the period that you want of this artist, or this is not an artist of sufficient importance to have in your collection. Yet, you just love the work anyway. That's what personal collections are all about.

Consciously or unconsciously, collecting American paintings is important to me in a special way. Those from an ethnic background like mine often have a great appreciation for America because of the opportunity this country has created for their families. The result is a deep love for one's country and a particular appreciation for the period in which the country grew and expanded. A love for one's country also instills a desire to give something back to it. I have lent paintings to many exhibitions. To some extent my collecting has been driven by wanting to share my paintings with others as a way of giving something back to the country that has been so good for our family.

Although I enjoy collecting and sharing the collection with others, I am a very private person. In fact, it is because of the personal publicity that inevitably results from an exhibition that I have been reluctant to have one before now. Yet, I believe strongly that it is important for people to appreciate the unique character, diversity, and quality of American art. I hope that the present exhibition will encourage others to both appreciate and collect American art.

Richard Manoogian

Reprinted with permission of the National Gallery of Art from *American Paintings from the Manoogian Collection,* exh. cat. © 1989 by the National Gallery of Art.

(In response to questions from Nicolai Cikovsky, Jr., Samuel Sachs II, and Nancy Rivard Shaw)

ACKNOWLEDGEMENTS

Celebrate America: 19th Century Paintings from the Manoogian Collection would not have been possible without the efforts of many individuals. Most importantly, our sincerest thanks to Richard Manoogian, whose generous loan of such an important selection of works from his collection created this beautiful exhibition. We are extremely grateful to Joan Barnes, Registrar of the Manoogian Collection, who worked closely with the Dixon staff and provided countless hours of information and support. She handled many different aspects of the exhibition including the press releases, the shipping arrangements, and all photographic and textual information. We would like to also thank Jonathan Boos of MASCO Corporation who helped frame the initial selection for the exhibition.

We are indebted to Dr. Nicolai Cikovsky, Jr, Senior Curator of American and British Paintings at the National Gallery of Art, who shared his expertise and time to compile, edit and in some cases write the forty-nine entries for this catalogue.

Special thanks to the Dixon's Consulting Curator, Dr. Richard R. Brettell, for his illuminating essay which explores the definition, history and social context of American art.

The Detroit Institute of Arts, National Gallery of Art and the Yale University Art Gallery kindly gave us permission to use abridged texts from their catalogues—*From the Hudson River School to Impressionism: American Paintings from the Manoogian Collection* (1997), *American Paintings from the Manoogian Collection* (1989) and *A Private View: American Paintings from the Manoogian Collection* (1993). In particular, we would like to thank James W. Tottis, Acting Curator of American Art, and Judith Ruskin, Editor of the Publications Department at The Detroit Institute of Arts; Frances P. Smyth, Editor-in-Chief at the National Gallery of Art; and Jock Reynolds, Director and Helen A. Cooper, The Holcombe T. Green Curator of American Paintings and Sculpture at the Yale University Art Gallery for handling our request.

Our warmest thanks to the authors of each entry, to whom we are indebted for their fine scholarship on the Manoogian Collection: Sarah Cash, Nicolai Cikovsky, Jr., Sarah Towne Hufford, Franklin Kelly, Sally Mills, Ronald G. Pisano, Nancy Rivard Shaw, Marc Simpson, D. Dodge Thompson, Alison Tilghman, James W. Tottis, and John Wilmerding. It is because of their thorough research for the catalogues listed above that their essays were reprinted, with changes, for this project.

Particular thanks goes to Joseph Orgill III, Chairman of the Board of Trustees at the Dixon from 1995–1997. It was through his direct involvement, leadership and sponsorship that the Dixon was able to pursue and ultimately secure what is undoubtedly one of the finest selection of American art ever shown at The Dixon Gallery and Gardens. We gratefully acknowledge the generous donation from International Paper.

This exhibition catalogue was created through the efforts of the Dixon staff including Vivian Kung-Haga, Assistant Curator, who was responsible for compiling the catalogue materials, proofreading and designing the cover. Appreciation is also due to Katherine Lawrence, Assistant Director, Neil O'Brien, Assistant Registrar and Sally Kee, Executive Assistant.

James J. Kamm

"AMERICAN" ART IN A "EURO-AMERICAN" CONTEXT: A PLEA FOR COSMOPOLITANISM

The Richard Manoogian Collection is among the best and best-known private collections of American art in the United States. Although its strengths lie in the period 1850-1915, the collection includes works from the late 18th through the 20th centuries and is among the handful of encyclopedic private collections of American art formed in this century. It has been shown in select American cities of the East, Midwest and South, and has even toured Japan in a landmark exhibition of 1997-1998. Unlike many of his compatriots, Richard Manoogian is supremely aware of the public responsibilities of a private collector and his willingness to share works from his collection with diverse audiences has created many opportunities for both Americans and foreigners to see works of American art— including art produced 1) by American artists in America, 2) by American artists abroad, and 3) by foreign artists whose careers were spent largely in America. Thus, the various limits of the concept "American" are approached in this superb and conceptually generous collection.

The selection of American art from the Manoogian Collection made for exhibition at The Dixon Gallery and Gardens in Memphis is particularly rich and thought-provoking, and it will be seen in an American institution whose painting collection is devoted almost exclusively to French art, creating a context to meditate on the differences—and similarities—between "French" and "American" art of the 19th and early 20th centuries. Like many Americans, both Mr. Manoogian and Mr. Dixon are—were, for Mr. Dixon—of foreign origins—Armenian and English respectively—and both are, in different senses, American. Mr. Dixon emigrated from England to the United States where his tastes and cultural expectations were formed and where he built a Georgian-style house, utterly at home in the South, filled it with English furniture and modern French painting. In this way, he was like many wealthy country gentlemen of the early and mid 20th century in England and like many American collectors from Chicago to Boston who favored English furniture and French pictures in an American setting. Richard Manoogian, on the other hand, began by collecting the contemporary art of America, wanting to contribute to the cultural vitality of his nation. Yet, as he continued to develop his own sensibilities, he became increasingly

interested in the period of American art that coincided with the immense economic and cultural fluorescence of this country—the period of America's self-definition that has been called everything from the "Gilded Age" to the even more grandiose "American Renaissance."

The last half of the nineteenth century and the early decades of the twentieth were critical for the nation's process of self-definition. Before the mid-twentieth century, the United States was remote from Europe and decidedly provincial. By the late 1910's, America lost her isolationism after entering the European theater of World War I. While writers like Hawthorne, Melville, and Twain attempted to define "America" through the novel and Walt Whitman sought to become the "American" bard, painters and sculptors also struggled to create a legitimate embodiment of "America" in the visual and plastic arts. They were helped in this enterprise by critics and collectors who decried foreign influence as pernicious and who valued images and styles that were apparently unaffected by European influence and, hence, were utterly "American." Yet, during precisely the same period, other collectors, other novelists, other artists, and other Americans spent considerable periods of time in Europe attempting to learn the various lessons of an older set of civilizations in order to better create models for a new nation. In many ways, it was the struggle between these two types of Americans—the global cosmopolitan and the deliberately unsophisticated "native"—which undermines any attempt to create a single definition of American art.

In the nineteenth century, when the majority of the works in the Manoogian collection were made, there were also two types of American collectors—one of variously "European" and "Euro-American" art (one thinks of James Jackson Jarves, J. P. Morgan, Martin Reyerson, and Henry Clay Frick) and another that made a conscious decision to "buy American." We must remember that a good deal of American self-confidence during this period came from mastering the languages and history of Europe without loosing one's sense of being an "American."

American artists, collectors, dealers, and museum professionals have spent more than a

century defining just what is meant by "American" art. They have mercilessly segregated it from European art in our major museums, creating separate departments and galleries as if to enshrine our own visual traditions in settings that protects them from European pollutants. And, in our universities, strong centers devoted to the study of American art have been set up more-or-less in opposition to the American study of European art. This has been done largely out of necessity. Both Europeans and globally sophisticated Americans have always looked down on what they deemed the provincial and isolationist tendencies of American art. In their consciously "larger" view, American art fails to compete effectively on an international scale until the mid 20th century, when even Europeans agree that New York superceded Paris as the world art capital. Before then, it is often said, there are isolated geniuses like Thomas Eakins, Winslow Homer, Georgia O'Keeffe, and Edward Hopper, but these artists, though important enough to be known, are never considered as "essential" in world art history as are their contemporaries Edgar Degas, Paul Cézanne, Wassily Kandinsky, and Henri Matisse.

Perhaps, for that reason, 20th century scholars, dealers, curators, and collectors of American art have always had a slightly defensive posture, claiming that American art has been persistently "underrated" or "misunderstood" by those who value European traditions. Their posture is not indefensible—there is a level of simple snobbism in the rejection of American art. Yet, like many other defensive positions, that of the "Americanists" has both critical and logical pitfalls. When one tries to build up the reputation of a "neglected" figure, one too often does so by attempting to tear down that of an acknowledged master. It is, for example, wrong to claim that Hopper is greater than Matisse (although he is greater than Albert Marquet, the French painter that Hopper emulated the most). But it is not wrong to attempt to add Hopper to an enlarged canon of 20th century art. This process is not accomplished most effectively by restricting one's consideration of Hopper's esthetic achievement to an utterly "American" context, and it is, in fact, the positioning of the very best of American art in the context of the very best of various European traditions that will insure that "American Art" is actually taken seriously globally.

The Dixon Gallery and Gardens is a very good place to do this, and this selection from the Manoogian Collection provides many high quality works that force comparison. Fortunately, the staff of—and visitors to—the Dixon are well prepared for this. As recently as last year, a superb group of American works from the National Gallery of Art in Washington was loaned to the Dixon in order to further an orderly process of education that is being significantly enhanced with the Manoogian paintings. With the Manoogian Collection, we start our investigation with a group of American works of the Hudson River School, our first self-consciously nativist landscape tradition. These artists were well-trained—indeed the spiritual leader, America's first great landscape painter, Thomas Cole, made several trips to Europe and actually represented European scenery and European historical scenes for America. Yet, in giving them an international context, we must remember that the only European nations with a national landscape school before the Hudson River School were Germany and Holland, and that the greatest painters of the Italian landscape in the 17th through the 19th centuries were not Italians, but visiting foreigners. Indeed, virtually every newly democratic nation of Europe "discovered" or "rediscovered" its landscape in the early and mid 19th century at precisely the same point that Americans began to make representations of their own wild landscape. While Cole and Church painted the American pioneers who lived off the land, Millet and Rousseau painted French peasants who made their livings from the natural bounty of France, and German, Swiss, Polish, and Russian landscape painters made extraordinary images of the wilder reaches of Europe. Indeed, the Hudson River School is part of a Euro-American and urban desire for images of "nature" made to be seen by industrial modernists who were more-or-less cut off from it in their daily lives. So much for its "Americanness."

If Cole and George Inness both spent considerable periods of time in Europe, this fact is underplayed in the books and articles about them produced by the legions of scholars and curators who devote their careers to "American" art. Recently the Dallas Museum of Art bought a major painting by Thomas Cole from the Metropolitan Museum, where it had been since the 19th century. The work was presumably "deaccessioned" simply because it represented a French landscape and was painted in Rome, thereby making it difficult to hang in the "American Wing." And what about the superb

European landscapes by George Inness, which have collectively a lower monetary value and which hang less often in "American" Galleries than do the same painter's "American" images of Massachusetts, New Jersey, or Florida. Is there really much sense in this?

It is with the artistic contemporaries of Henry James—Whistler, Cassatt, and Sargent, to name the most prominent—that we get into very dicey territory when it comes to their "Americanness." In each case, the paintings of these three artists are routinely hung in the American galleries in the great museums of Boston, New York, Philadelphia, and Chicago, to name only the most prominent collections. This, in spite of the fact that all three artists spent virtually their entire working lives in Europe and that the majority of their closest colleagues and friends were English or French artists. Cassatt, for example, was closer to Edgar Degas and Camille Pissarro than she was to *any* American artist, man or woman, and the same claims can be made for Whistler and Sargent. (Thank God for the Chester Dale Galleries in the National Gallery in Washington, because his wonderful group of works by Cassatt actually hang with the French paintings to which they have the closest esthetic relations.) These, our first great cosmopolitan artists, are actually hobbled by their position in "American" galleries and books.

Fortunately, the Manoogian collection has never been narrow about its definition of American art and, for that reason, there is a wonderful sampling of works by major and minor American artists of the last decades of the 19th century who learned to make art in Europe, who spent considerable time in Europe, and who routinely sent their works to French and English exhibitions for validation. Indeed, the sheer generosity that Richard Manoogian has given to his definition of "American" is one of the truly important aspects of his project as a collector.

One of the major differences between "American" and "French" artists that will be apparent to visitors of the Manoogian Collection at The Dixon Gallery and Gardens has to do with the concept of "finish." A walk through the Dixon's own collection of works by Monet, Sisley, Renoir, Degas, Pissarro, and others will show that these artists valued a mode of painting in which each of their pictorial gestures is part of the meaning of the painting. For them, *how* the picture was painted is even more

important to our interpretation of it than *what* it represents. A walk through the Manoogian Collection will reveal that American artists preferred a traditional sense of "finish" in which the artist worked to achieve a uniform pictorial surface free of individual painted marks. In this way, the "skill" of the artist is in creating a representation that it so lifelike that it is relatively easy for the viewer to "enter" the realm of the picture. In this way, "depths" are more interesting to American artists than "surfaces," and subject is more important than process. Yet, to make this simple conclusion in such an extreme fashion would be a mistake. In fact, the majority of works in the Dixon's collection have been selected from the vanguard minority of artists in France rather than from the work of French artists who were familiar to most 19th century Americans. Americans were more familiar with Gérôme, Bouguereau, LeFebvre, Breton, l'Hermitte, and Bastien-Lepage—painters who would be called "academic" today—than they were with the works of the Impressionists and Post-Impressionists whom *we* know better. What we learn from the comparison at the Dixon is that American collecting of "French" modern art is so biased in favor of the avant-garde that we don't have the same idea of "French" art as did American artists who traveled to France in the 19th century! Hence, in many ways, the comparison of the Dixon's and Manoogian's collections *can* lead us to false conclusion, if we are not careful with the terms of our comparison.

The opportunity to study a landscape by Inness of 1868 in the Manoogian Collection and to rush a few galleries away and compare it with a Corot or a Monet or a Pissarro in the Dixon Collection is to enrich our understanding of *both* French and American art. The sheer ambition of Inness, his belief in the independence of color and the painted mark, the simple eloquence of his gestures—all of this makes it clear that his oeuvre is at an equal level to that of his French compatriots. Yet, were we to run into any of these paintings in a commercial gallery, we would know that three of them were French and the other American. Why? Strangely, the answer has less to do with any "real" qualities of them as works of art, than with the fact that we have learned from museums and art books just what "French" or "American" landscapes look like. In fact, Inness's landscapes are constructed on esthetic principals that are very little different than those of Monet or Pissarro. The differences that *do*

exist are crucial. For Inness, painting was structured both by "tones" of light and dark and by "colors." For the Impressionists, there were no "tones," only colors, and they were able to see a shadow on a building or a tree not as a darker portion of the building or the tree, but as a series of colors in their own right. In this way, the sheerly optical quality of French Impressionism makes it different from Inness's esthetic. What would be "wrong" about making conclusions from this sample alone is that we might decide that French painting is "better" than American painting because it is more conceptually advanced. In fact, the Impressionists *were* more conceptually advanced. Yet Inness, in this particular case, was fully aware of Impressionist theory and actually rejected it—giving his work a quality of independence that he sought. He was *not* unsophisticated and, therefore, "American."

This small digression into the problems of discussing "American" or "French" esthetics in strictly nationalistic terms is fully necessary if we are to make the most of the extraordinary Manoogian loan of American paintings to The Dixon Gallery and Gardens. What we have learned is that simple generalizations about "French" qualities in art from the Dixon collection are as fraught with peril as analogous generalizations about "American" art from the Manoogian collection. Indeed, what we can experience from the contrast between the two collections is that the Manoogian Collection is a fairer sample of the diversity of American art than the Dixon Collection is of French art.

The actual history of European and American Art of the period 1850-1930 is a deeply intertwined and interrelated history that makes such national categories almost meaningless. Not only did the Frenchman Degas have family in Italy and the United States and the Danish Pissarro grow up in the Virgin Islands, but the Americans Sargent, Cassatt, and Whistler lived most of their lives and died in Europe. It is no longer necessary to apologize for American art, to create a sort of institutional petri dish for its nurture far from the "germs" of Europe. It is also unnecessary to claim that only the "French" could make "French" art in the 19th and 20th centuries. Indeed, where would French art be without the Dane Pissarro, the Englishman Sisley, the Dutchmen van Gogh and Mondrian, the Spaniards Picasso, Gris, Miro, and Dali, the Americans Whistler, Cassatt, and Sargent, the Italians Martelli, Severini, and Boccioni, the

Czech Kupka, and on and on? And where would American art be without such "foreigners" as Bodmer, Bierstadt, Sorolla, Zorn, Stella, Gleizes, Duchamp, and Leger, all of who spent years in the United States?

If we are a nation of immigrants, we might equally argue that modern art is an art of exiles, tourists and immigrants and that transnationalism is an important component of modern civilization. In celebrating this exhibition of American painting collected by an Armenian American from Detroit in a museum of French art started in Memphis, Tennessee by an Englishman, it is necessary not only to accept, but to celebrate the cosmopolitanism that is at the very core of modernity.

Richard R. Brettell, PhD.
Consulting Curator
The Dixon Gallery and
Gardens

CONTRIBUTORS TO THE CATALOGUE

Sarah Cash

Nicolai Cikovsky, Jr.

Sarah Towne Hufford

Franklin Kelly

Vivian Kung-Haga

Sally Mills

Ronald G. Pisano

Nancy Rivard Shaw

Marc Simpson

Alison Tilghman

D. Dodge Thompson

James W. Tottis

John Wilmerding

1

Otto Henry Bacher
1856-1909
Ella's Hotel, Richfield, Ohio, 1885
Oil on canvas, 31 x 42½ in (78.7 x 107.9 cm)

Today, Otto Bacher is best known for his con-
nection with James McNeill Whistler, whom he
met in Venice in 1880. Many years later he
wrote an important book about him, *With
Whistler in Venice* (1908), and he was a prolific
etcher in a manner strongly influenced by
Whistler.

Ella's Hotel, Richfield, Ohio shows little of
Whistler's idiosyncratic style, and little either of
the Impressionist handling and color that came
to characterize Bacher's paintings beginning
about 1890. In 1883 Bacher, with his friend the
painter Joseph De Camp, whom he knew from
Italy, taught at Richfield, a town located south
of Cleveland, Bacher's birthplace. In some way
that is not clear, the painting seems to be a
memento, deliberately American in its flavoring,
of that experience. The man in the buckboard
is said to be a Dr. Ewing, whose sons studied
with Bacher at Richfield, and through whose
family the painting descended. Bacher added to
his signature at the upper right "Buck Eye
State." *NC*

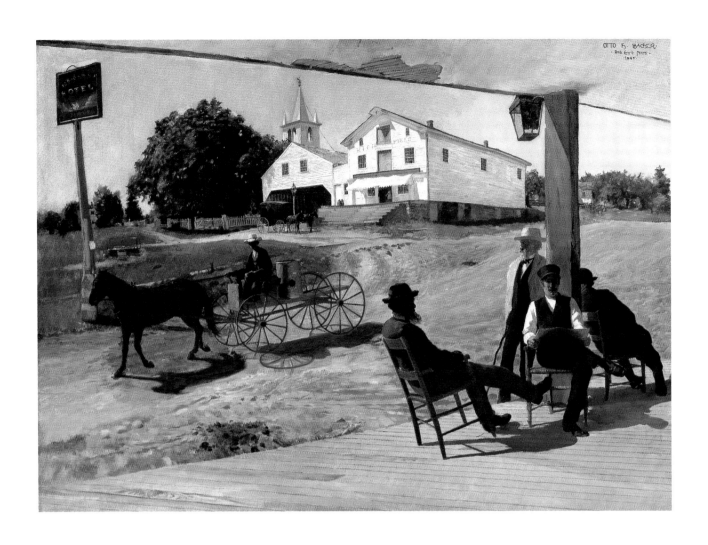

2

Frank Weston Benson
1862-1951
Summer Afternoon, c. 1906-1908
Oil on canvas, 30 x 40 inches (77.5 x 130.3 cm)

Frank Benson began to experiment with the techniques of Impressionism as early as 1898, but he did not begin to work outdoors regularly until 1901, when he bought a summer house on an island in Maine. The casual, sunlit summer idylls he produced there are, as a group, the best paintings he ever made.

Summer Afternoon, according to family tradition, was painted in 1906 but not exhibited until 1908. It depicts his favorite models, his daughters Elizabeth, Sylvia, and Eleanor, joined by the family dog. The entire canvas is a carefully worked-out pattern of light to achieve the effect of the intense, unfiltered summer light of the Maine coast. The whites of the dresses reflect the surrounding colors, and emphasize them; the blues, browns, and reds are more intense because of their subtle quotation in the whites of the dresses.

Although all the members of Benson's family served him as models, his depiction of his daughters received the most critical attention. Charles Caffin saw in them "a new type... something of the character of a fine-blooded racehorse, long, in its lines, clean cut, spare of flesh...a product of intense breeding—a cross between the exacting narrowness of Puritanism and the spiritual sensuousness and freedom of Emerson."[1] *NRS*

[1]"The Art of Frank W. Benson," *Harpers Monthly Magazine* 119 (June 1909), 106.

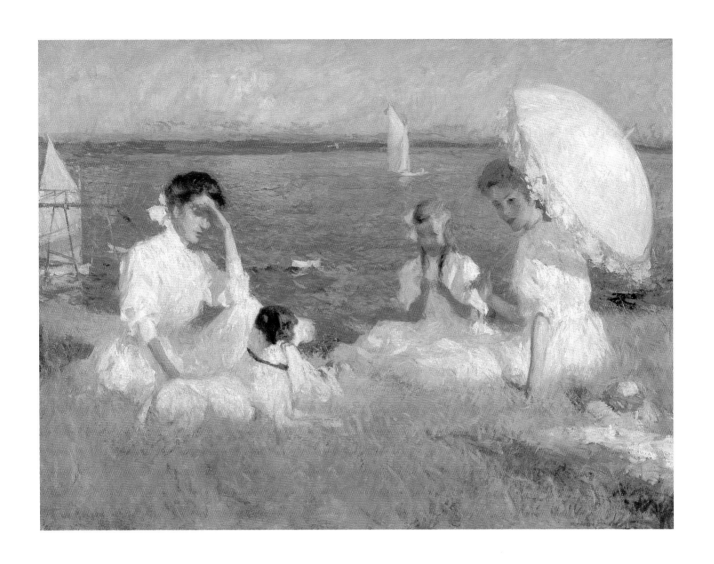

3

Albert Bierstadt
1830-1902
Platte River, Nebraska, 1863
Oil on canvas, 36 x 57½ inches (91.4 x 146 cm)

Bierstadt was the leading figure of the second generation of the Hudson River School to travel west, and he rendered impressive scenes for eastern audiences. *Platte River, Nebraska* was based on sketches made from his first western expedition in 1859. In keeping with earlier Hudson River painters, Bierstadt depicted the human figure as small and insignificant in comparison to the overall landscape, emphasizing nature's power over humans and the majesty of the American landscape.

The expedition party is depicted on the right of the winding river, whose treacherous falls and rapid current begin to calm as the tributary snakes toward the west. Visible through the distant prairie grass and the vegetation growing along its banks, the river represents fertility and growth. Frontiersmen, veiled in shadow, head toward the expansive, sun-drenched plain leading to the regal mountains. Expressive clouds interact with the powerful landscape to heighten the dramatic effect of the composition. These elements symbolize the importance of westward expansion in fulfillment of the nation's "Manifest Destiny."

The heavily shadowed foreground, the choppy water, and the falls reflect the influence of Thomas Cole. Like his predecessor, Bierstadt depicted humans emerging from the confines of the East and progressing toward virgin territory, as yet undiscovered by what was considered "civilized man." However, the similarly unspoiled landscape of Cole's time, a generation earlier, was no further west than the Allegheny Mountains of Pennsylvania or the Hudson River. *JWT*

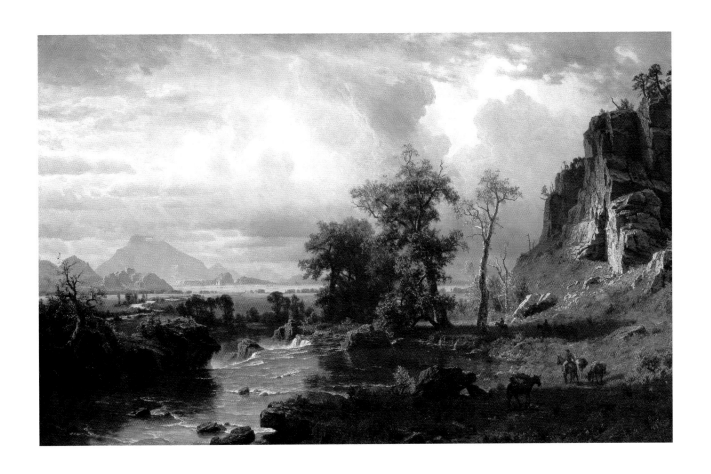

4

Robert Frederick Blum
1857-1903
Flower Market, Tokyo, c. 1892
Oil on canvas, 31⅝ x 25⅜ inches (79.1 x 63.8 cm)

Robert Blum conceived a "wild desire" to visit Japan while he was still a teenager in his native Cincinnati. When at last he managed to visit in 1890 he was not disappointed: "[It] is the most glorious experience I have ever had," he wrote his friend Otto Bacher a few weeks after he arrived, "You know that delightful glamour that is cast over everything when you are in love? This is what Japan is to me just now and I am praying to God to keep it for me. I am treading enchanted soil. It is the one experience of my life where the expectation was fully realized after all the wild vague day dreams."[1]

Blum's two major Japanese paintings are *The Ameya* (Metropolitan Museum of Art, New York) and the Manoogian *Flower Market, Tokyo*. Blum is known to have collected photographs in Japan, and the unusual juxtaposition of the figures and sharply receding perspective suggest that he used them to construct *Flower Market, Tokyo*. However, it is evident from Blum's diary that he used sketches—he was a gifted draughtsman—to arrange his compositions. He also posed his gardener, Fuyji, for the flower peddler,and his maid, Sing, for the woman shopper.

On his return to New York, Blum exhibited *Flower Market, Tokyo* at the Society of American Artists in April, 1893. To the eyes of critics used to the Impressionist paintings that had for several years appeared in growing numbers in New York exhibitions, Blum's painting seemed outdated: "One reason why the extremely clever Japanese pictures of Mr. Robert Blum, like *Flower Market, Tokyo*, leave us vaguely dissatisfied, spite of the nice color values and pleasing, crisp drawing, spite of the novel scene and excellent characterization of the people, is that Mr. Blum has not been through this practice of analyzing light and does not give us in his pictures the vivid sense of out of doors to which [the Impressionists] have accustomed us."[2]

Despite the mixed reception at its debut in 1892, *Flower Market, Tokyo* helped Blum achieve a bronze medal at the Exposition Universelle in Paris in 1900, and earned him a gold medal at the Pan-American Exposition in Buffalo in 1901. *DDT*

[1] Robert Blum to Otto Bacher, Tokyo Hotel, 22 June 1890. Otto Bacher Papers, Archives of American Art, Smithsonian Institution. Blum Arrived in Japan on 6 June 1890.

[2] "The Society of American Artists. Shows the Effect of the Modern Study of Sunlight," *New York Times* (24 April 1893).

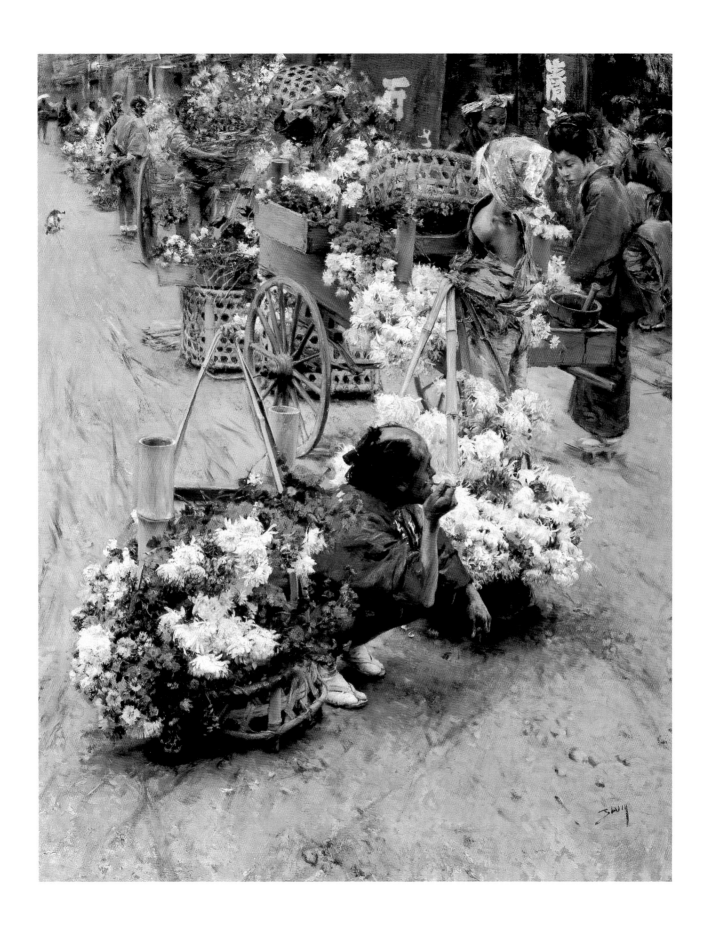

5

Alfred Thompson Bricher
1837-1908
View on the Providence River, 1877
Oil on canvas, 25⅛ x 50⅛ inches (63.8 x 127.3 cm)

Alfred T. Bricher was very much a creature of artistic habit. In a career of more than thirty years, he seldom forsook his favorite subjects or tried-and-true pictorial conventions—coast scenes with a bit of beach and a mass of rocks at right or left with a view to open sea, painted from sea level and on a format twice as wide as high occur again and again in his art. Bricher was an acute observer and had a refined sense of color, light, and composition, all of which relieved and redeemed what might otherwise be an unbearably repetitious pictorial formula. In *View on the Providence River,* however, with its wonderful range of textures, the dramatic flash of light on the water, its subtly cadenced accents, and almost oriental compositional balance, that formula is varied in unusually beautiful and subtle ways.

View on the Providence River was painted from drawings that Bricher made six years earlier on a visit to Narragansett Bay in the summer of 1871. What is more, it was assembled from drawings made at two geographically separated places.[1] Effects of light and atmosphere that seem so directly seen, and a subject so intensely specific in its features, therefore, are in fact largely the products of practiced visual memory and accomplished pictorical artifice. *NC*

[1] See Robert G. Workman, *The Eden of America: Rhode Island Landscapes, 1820-1920* [exh. cat., Museum of Art, Rhode Island School of Design] (Providence, 1986), 57, entry 31. Jeffry Brown very kindly shared his unrivaled knowledge of Bricher and gave free access to his extensive files on the painting. This painting has also been titled *Looking Seaward at Beverly.* Robert R. Perron, Marine Curator, The Beverly Historical Society, believes that the painting could have been made at Beverly, *executed from a location on the westerly side of Curtis Point, in Beverly, at about 10 a.m., looking SSE toward Marblehead Neck and Peaches' Point.* The day beacon on Haste Rock is still there, though in a different form, and a lighthouse has long been located on Marblehead Neck; the sandy beach is now severely eroded. But if the painting does indeed depict Beverly, Bricher used considerable artistic license, deleting islands and changing the perspective. (Letter to the author, 22 December 1988, which is most gratefully acknowledged).

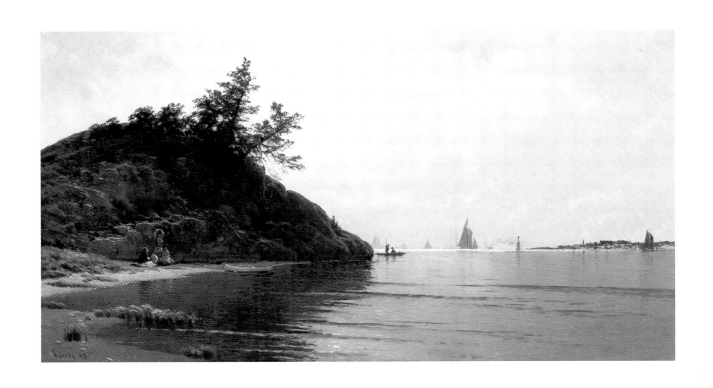

6

John George Brown
1831-1913
Hiding in the Old Oak, n.d.
Oil on canvas, 23½ x 15 inches (59.7 x 38.1 cm)

Hiding in the Old Oak is a study for, or a copy after, a larger painting of the same subject and title (St. Johnsbury Athenaeum, Vermont) which Brown exhibited with great success at the National Academy of Design in 1874. Though Brown would later specialize in depictions of urban child-life, particularly bootblacks and newsboys, in the nostalgic period following the Civil War, his genre scenes focused on rural children. Brown was not alone in this choice. Eastman Johnson and Winslow Homer also produced images of country childhood in the 1860s and 1870s. All three artists shared an interest in naturalistic outdoor effects, and their paintings often suggest reciprocal influence.

Girls were the focus of Brown's rural scenes, usually posed in sun-dappled forest interiors, sometimes leaning against large foreground trees. In this example, three young girls stand in the hollow of a massive oak tree, presumably playing a game of hide-and-seek and waiting to be found by an unseen playmate. Their mood of quiet anticipation evokes the feelings associated with childhood play, but it also suggests the uncertainties of adolescence and approaching womanhood. The composition and treatment of light in this painting recall Brown's earlier depictions of girls amid trees, a motif that may have its source in English Pre-Raphaelite works by John Everett Millais and Arthur Hughes, whose works were well known in the United States.[1] *NRS*

[1]Martha J. Hoppin, *Country Paths and City Sidewalks: The Art of J. C. Brown*. [exh. cat. George Walter Vincent Smith Art Museum] (Springfield, Massachusetts, 1989), 10.

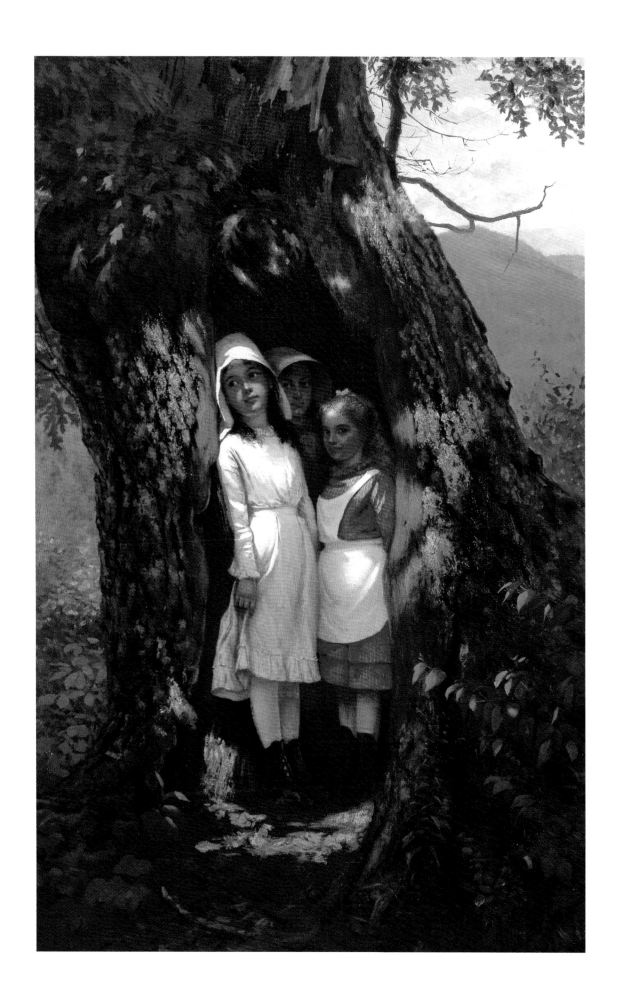

7

John George Brown
1831-1913
Sunshine, 1879
Oil on canvas, 14⅛ x 20⅛ inches (35.9 x51.1 cm)

Less well known than his paintings of shoeshine boys and other urban street urchins, J. G. Brown's *Sunshine* was executed in the earlier part of his career, when many of his works reveal his interest in observing and translating the effects of natural light into oil on canvas.[1] In *Sunshine,* Brown has captured the bright but hazy atmosphere of the seashore.

In the 1860s and 1870s, Brown's outdoor scenes rivaled those of Eastman Johnson and Winslow Homer. Similarities in the work of these three artists imply that they influenced each other. All had studios in New York; Brown and Homer worked in the Tenth Street Studio Building from 1872 through 1881. Brown began painting pensive young middle-class women alone outdoors by the mid-1860s, several years before Homer was to do so.[2] The resemblance of the girl and her costume in *Sunshine* to those in a Homer drawing and a related painting of 1878 suggest a particular instance in which Brown may have been familiar with Homer's work or they may have used the same model.[3] *STH*

[1] *Sunshine* must be the same painting as *A Sunny Day,* which Brown exhibited in 1879 at the National Academy of Design. A review in the *New York Times,* 20 April 1879, 10, describes *A Sunny Day as ... a full-length minature portrait of a young girl lying on a sandy hillock on the beach.* Martha Hoppin has graciously provided this information from her monograph on John George Brown.

[2] Linda Ayres, "The American Figure: Genre Paintings and Sculpture," in *An American Perspective: Nineteenth-Century Art from the Collection of Jo Ann and Julian Ganz, Jr.* [exh. cat., National Gallery of Art] (Washington, 1981), 54.

[3] The drawing by Homer is illustrated in *Winslow Homer, 1836-1910, A Selection from the Cooper-Hewitt Collection, Smithsonian Institution.* [exh. cat., Cooper-Hewitt Museum] (Washington, 1972), cat. 40. The related painting is *Peach Blossoms* in the Art Institute of Chicago.

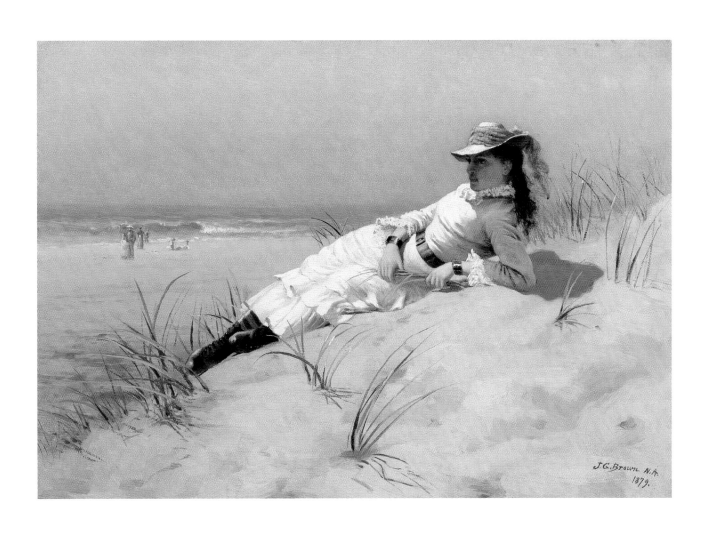

8

William Merritt Chase
1849-1916
The Nursery, 1890
Oil on panel, 14⅜ x 16 inches (36.5 x 40.6 cm)

Beginning in the late 1880s, Chase began a series of paintings of the public parks of, first Brooklyn (Prospect Park) and later New York (Central Park). In his paintings of Central Park especially, while he painted well known places, he more often discovered neglected and out-of-the-way subjects, finding beauty, one critic wrote, "in things we have heretofore called dull and uninteresting," and seeing, as another said, "the unexpected charm [of] some corner neglected by the public."[1] *The Nursery* is such a subject. Located in the upper reaches of the park, it was a little-frequented place where seedlings were grown for planting elsewhere in the park's public spaces. But of this subject, prosaic and with challenging angularities of shape, Chase made one of his most beautiful paintings. It was Chase's belief, perhaps even his central artistic conviction, that it was not subject matter that made a picture beautiful, but how it was painted, how it was given artistic form. "People talk about poetical subjects in art," Chase said, "but there are no such things. The only poetry is the way an artist applied his pigments to the canvas."[2] *RP*

[1]Perriton Maxwell, "William Merritt Chase-Artist, Wit, and Philosopher," *Saturday Evening Post* (4 November 1899), 347; Charles De Kay, "Mr. Chase and Central Park," *Harper's Weekly* 35 (2 May 1891), 327.

[2]Maxwell 1899, 347.

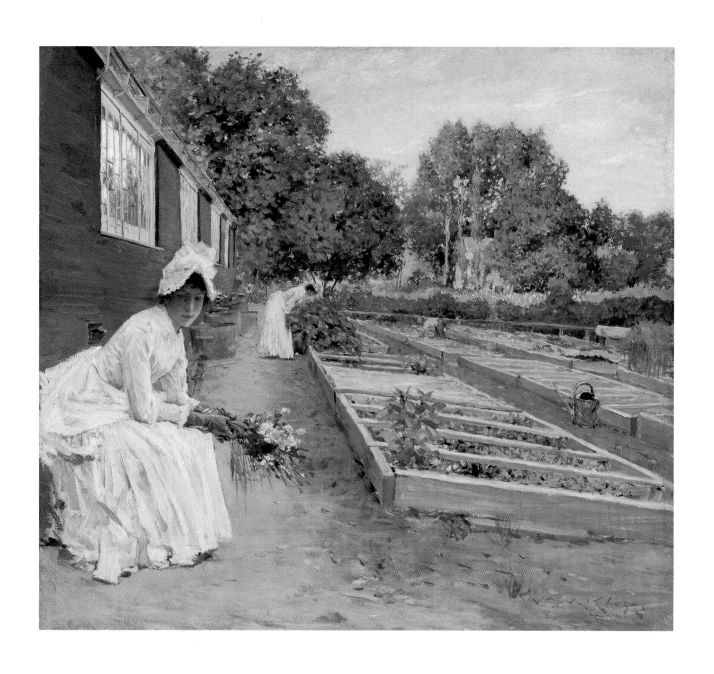

9

Frederic Edwin Church
1826-1900
July Sunset, 1847
Oil on canvas, 29 x 40⅜ inches (73.7 x 102.6 cm)

Church's early works, especially those of 1845-1847, were strongly influenced by his teacher, Thomas Cole. As one of his contemporaries wrote of *July Sunset*: "The first glance at this picture impresses one with the idea that it must be one of Cole's."[1] Church's paintings, however, are more matter-of-fact than Cole's. From the first, Church strove for a more realistic depiction of the world than did his teacher, and although he would occasionally be criticized for having "sacrificed general resemblance to detail," he would increasingly be praised for his "appreciation of the fine qualities of nature."[2]

July Sunset depicts a scene along Catskill Creek, a picturesque stream on the west bank of the Hudson River that Church had come to know well during his two years of study with Cole in the village of Catskill. Church roamed the surrounding countryside, often with Cole, or sometimes with Cole's young son, Theodore (probably the child at the lower left of *July Sunset*), making careful sketches of both broad vistas and small details of scenery. Later, established in his own studio, Church drew inspiration from his student sketches for many of his first paintings (a drawing of the present composition is in the Cooper-Hewitt Museum, Smithsonian Institution, New York).

July Sunset was one of two paintings Church sent for exhibition at the National Academy of Design in the spring of 1847. The other, a large and dramatic picture entitled *Christian on the Borders of the 'Valley of the Shadow of Death,' Pilgrim's Progress* (1847, Olana State Historic Site, Hudson, New York), also reflected the profound influence Cole had on the young artist, for it is clearly indebted to his allegorical and moralizing works. *FK*

[1]"The Fine Arts. Exhibition at the National Academy of Design. Second Saloon," *The Literary World* (5 June 1847), 419.

[2]"The Fine Arts," 419.

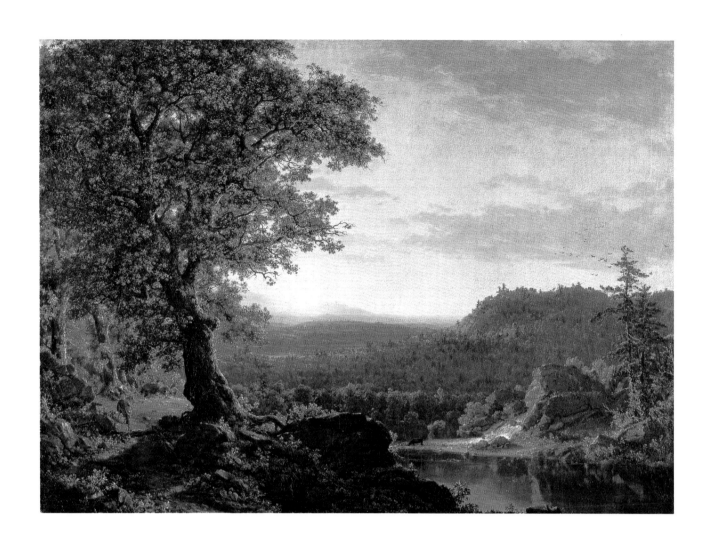

10

James Goodwyn Clonney
1812-1867
The Trappers, 1850
Oil on canvas, 17⅜ x 14 inches (44.1 x 35.6 cm)

The Trappers, exhibited at the American Art
Union in 1850, is a fine example of Clonney's
rural genre scenes. In its composition, it may
have been influenced by William Sidney
Mount's earlier depictions of the subject, his
Catching Rabbits (Boys Trapping) of 1839 and
Trap Sprung (The Dead Fall) of 1844. Although
each has a boy holding a rabbit while his
companion resets the trap, Clonney has
arranged the two figures differently. The com-
pact composition and silhouetting of the figures
against the sky emphasize the captured prey.
The lively pose of the boy holding the rabbit
adds a sense of triumph, explained by the
shadow of a figure at the lower left, toward
which both the gaze of the kneeling boy and
the upheld rabbit are directed. The subject of
young boys portrayed as hunters alludes to the
realities of rural life in which boys were
expected to kill animals for food or fur.[1] The
reference to the unseen and presumably older
third person whose approval they seem to be
seeking suggests that this is a learning experi-
ence for the boys. *STH*

[1]Patricia Hills, *The Painters' America, Rural and Urban Life, 1810-
1910,* (New York, 1974), 34.

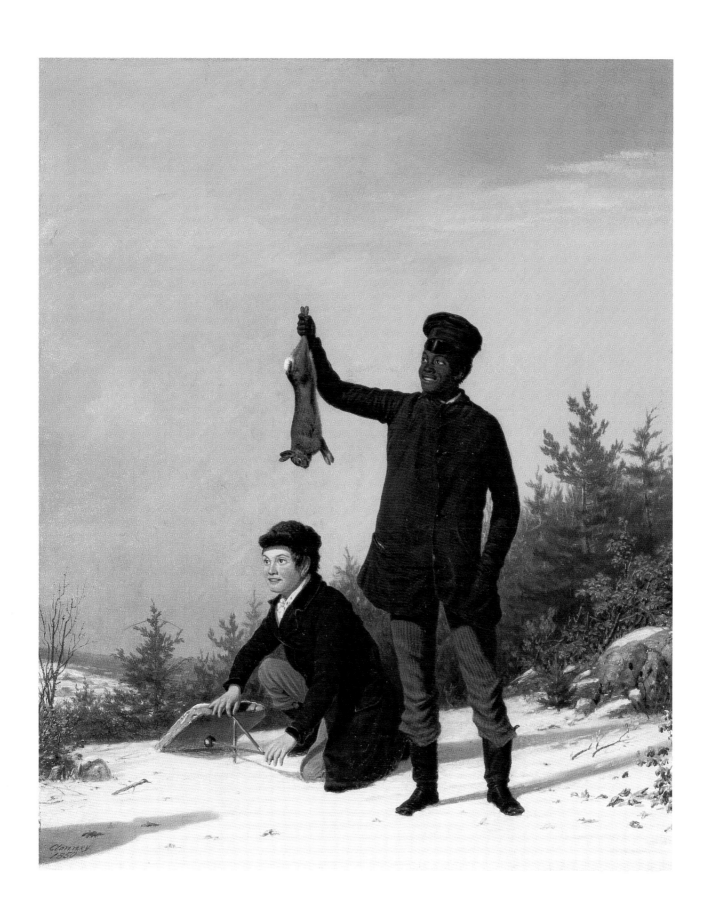

11

Charles Courtney Curran
1861-1942
Chrysanthemums, 1890
Oil on canvas, 9 x 12 inches (22.9 x 30.5 cm)

Curran was already a fine draftsman and
designer before going to Paris in 1889. In Paris,
he turned to a more colorful palette, though his
figures, always of healthy young women and
girls, remained carefully rendered. This depic-
tion of a woman and a young girl admiring the
display of potted chrysanthemums in what
appears to be an open-air market was painted
in Paris in 1890. In addition to scenes like this
one that record and interpret contemporary
Parisian life, Curran also painted poetic,
Symbolist-inspired images of nudes and flowers;
for example, *Sunbeams and Dewdrops* (ca.
1890; The Manoogian Collection) and *Scent of
the Rose* (ca. 1890; private collection).
Throughout his career, Curran preferred solidly
drawn profiles, which reflected the mastery of
the human form he had achieved by drawing
from casts. His concern for abstract design—
evident in the bold diagonal thrust of the
composition and the patterned backdrop of roof
and flowers—reflects his awareness of Japanese
design principles. The subject of chrysanthe-
mums was probably also chosen for its oriental
associations. According to a French gardening
manual printed in 1854, this flower, "raised by
the Chinese to a rare degree of perfection, has
become all the rage in Europe ever since
horticulturists have taken to sowing its seeds
and developing varieties with a wide range of
hues."[1] *NRS*

[1]Robin Jaffee Frank, *A Private View: American Paintings from the
Manoogian Collection* [exh. cat., Yale University Art Gallery] (New
Haven, 1993), 27-31.

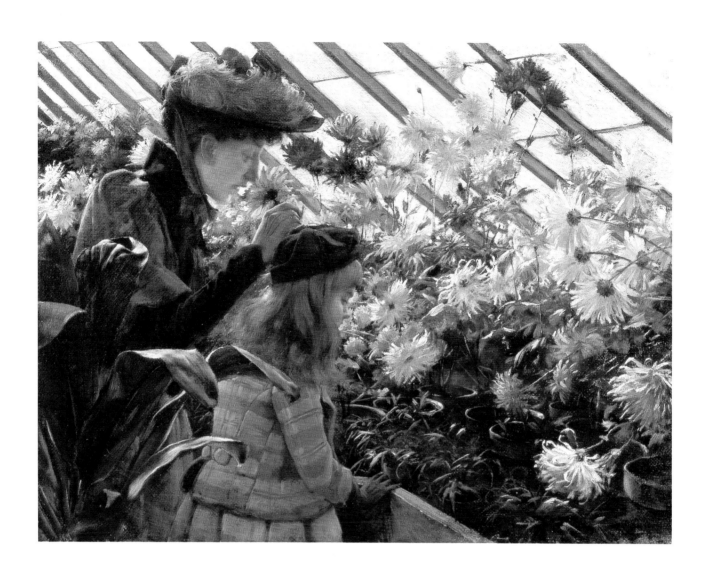

12

Thomas Wilmer Dewing
1851-1938
The White Birch, c. 1896-99
Oil on canvas, 42 x 54 inches (108 x 136.8 cm)

Dewing was admired particularly for his paintings of women in summer landscapes, rendered in muted tones of blue and green on coarsely woven canvases. Most were done at the artists' colony at Cornish, New Hampshire, where Dewing and his wife, the artist Maria Oakey Dewing, summered from 1885 to 1905. There, a group of dedicated artists with common aesthetic goals relaxed at the end of the workday with walks, picnics, and pageants in the countryside. Inspired by the lovely forms of the ladies and the beauty of the landscape surrounding them, Dewing produced more than a dozen major canvases, including *The White Birch*.

Dewing developed his refined tonal style under the influence of both James McNeill Whistler and oriental art. Rejecting Impressionism, Dewing sought to convey a poetic and imaginative world where, according to the artist, "only a few choice spirits live."[1] Dewing called these works "decorations," for he composed them not as transcriptions of nature, but with more abstract qualities in mind. They were earmarked for a select clientele—for instance, Stanford White, the famous architect who designed most of Dewing's frames, including the one for this painting. The Detroit businessman and art connoisseur Charles Lang Freer (founder of the Freer Gallery of Art, Washington, D.C.) was another important Dewing client.

If not for the slender tree and the tiny, flower-like figures, it might be difficult to recognize *The White Birch* as a landscape. Indeed, as is true of all of Dewing's mature work, the real subject of the picture is the beauty of its painted surface. Some contemporary reviewers were puzzled by the imaginative thrust of Dewing's art, but a few perceptive critics recognized the quality of his work. One declared Dewing "the most remarkable of modern painters...he works like a musician to a symphonic scheme; and the harmony of his pictures, so rhythmic, vibrating, and melodious, affects one in the way of stringed music...interpreting to one's capacity for intellectual sensuousness the most exquisite suggestions of form, tone, and texture."[2] *NRS*

[1] Susan Hobbs, "Thomas Dewing in Cornish, 1885-1905." *The American Art Journal* 17, no. 2 (spring 1985), 2-32

[2] Charles H. Caffin, "The Art of Thomas Dewing" *Harper's New Monthly Magazine 116* (December 1907), 714-24.

13

Robert Spear Dunning
1829-1905
Apples, 1869
Oil on canvas, 19¾ x 25⅜ inches (50.2 x 64.5cm)

From his studio in Fall River, Massachusetts, Robert S. Dunning produced a plethora of still-life paintings that found their way into collections throughout the Northeast. His work typically consisted of an ornate piece of crystal or silver surrounded by a bounty of lush fruit. These seductive compositions frequently contained a honeycomb and a decorative fabric, all resting on a highly polished table.

In *Apples,*[1] however, Dunning departed from his opulent Victorian fruit pieces, and turned his composition into a moral commentary. The abundantly filled bag spills forth apples, sharing its bounty with the tattered straw hat; thus contrasting the believed relationship between bounty, plenty, and wealth to that of want, need, and poverty, and the joy of charity and giving. Dunning made a similar statement in his undated pendant *Still Life* (Samuel J. Doinsife Collection), where he added human elements to his composition to illustrate the act of giving or charity.[2]

Even though Dunning's work was not in the vanguard, his appeal was high. Bryant Chapin of the *Fall River Evening Herald* mentioned *Apples* in his review of the Dunning memorial show. "The old hat is amazingly natural both in color and texture and the tree trunk is worked out in infinite detail but keeps its place in complete subordination to the rest of the picture. Taken as a whole it is a unique concept and finely handled." His review continued, "Poetic feeling and refinement are rare qualities in still life pictures but they exist in these pictures to a high degree."[3] *JWT*

[1]This work has been previously exhibited as *Autumn's Bounty.* The present title is based on historical descriptions of the work.

[2]William H. Gerdts and Russell Burke, *American Still Lift Painting* (New York, 1971), 174.

[3]*Fall River Evening Herald,* 14 December 1911, 15.

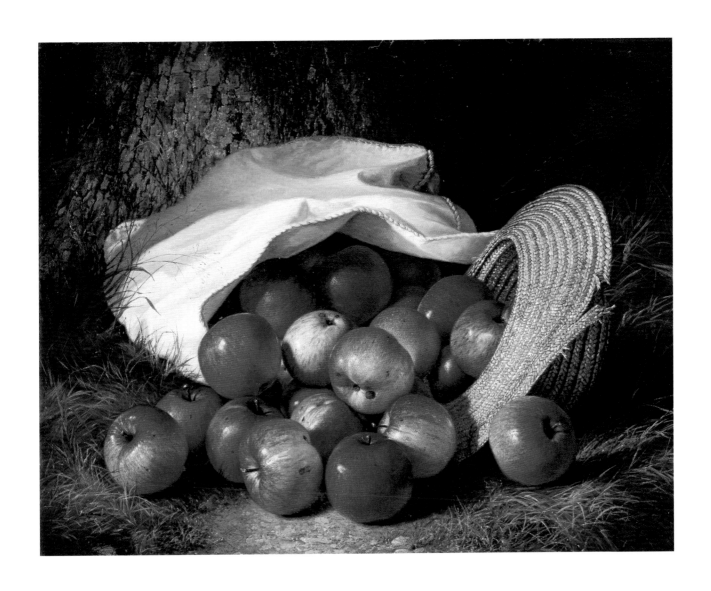

14

Asher Brown Durand
1796-1886
June Shower, 1854
Oil on canvas, 33⅛ x 48⅛ inches (84.2 x 122.2 cm)

Asher B. Durand is usually thought of as a painter of gentle pictures of pastoral fields and mountains or still, wooded interiors. When he included passing showers in his landscapes, they usually appeared in the role of refreshing and cleansing nature. On the whole, Durand said, he loved "Sunshine [as] the joyous expression of Nature," but he also admitted to being thrilled by "dark rain-clouds, agitated and convulsed with awful threatenings..."[1] Nevertheless, he only rarely portrayed the full fury of a thunderstorm, and in no other pure landscape did he do so as effectively as in *June Shower.* One critic who saw the painting at the National Academy of Design in 1854 said, "compared with the emotional intensity of the real storm, it is as ineffectual as a candle at noon-day."[2] Generally, though, the painting was admired. One writer praised "the lurid and watery clouds, and the peculiar tints lent for the moment to the foliage."[3] And later, in his *Book of the Artists,* Henry Tuckerman wrote, "It is a masterly work; in breadth, freedom, and vital truth equal to the artist's best efforts."[4] *FK*

[1] Durand, "Letters on Landscape Painting," nos. VI and VIII, *The Crayon* 1 (1855), 209, 355.

[2] "The Fine Arts. Exhibition of the National Academy of Design (Second Article)," *New-York Tribune* (22 April 1854).

[3] "Fine Arts. National Academy of Design (Second Notice)," *The Albion* (15 April 1854) (New York, 1867), 189.

[4] (New York, 1867), 189.

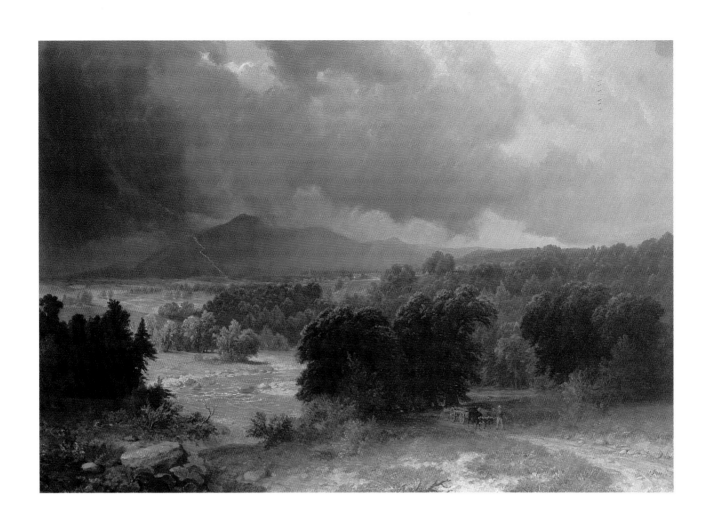

15

George Henry Durrie
1820-1863
The Half-Way House, 1861
Oil on canvas, 36 x 53¾ inches (91.4 x 136.5 cm)

A typical example of Durrie's mature work, *The Half-Way House* depicts a New England inn at the dawn of a winter's day. Featured in the center of the canvas is a group on a sleigh ride, a favorite pastime of the artist. Durrie's paintings were unusual for his time in that they combine elements of both landscape and genre painting. Also unlike most nineteenth century American landscape painters, Durrie usually painted winter scenes, which were his most popular and sought-after subjects. Ideas developed by the Hudson River School painters are clearly evident in his canvases; however, he departed from them in prominently representing human experiences.

The combination of picturesque buildings, domesticated animals, and leisure activities creates a sentimental view that the American public found appealing. This accounts for Durrie's rise to fame, particularly through his work with Currier & Ives, whose lithographs popularized many of his paintings, thus increasing the demand for his work. Currier & Ives often commissioned similar scenes from Durrie.

The Half-Way House was probably one of Durrie's entries in the 1862 exhibition at the National Academy of Design. The painting's size—it is one of Durrie's largest—and its complex composition, with multiple vignettes against a dramatic landscape background, suggest that he intended this to be his *tour de force.* Further evidence of this is the inclusion of the bearded man in the sleigh, which is considered to be a self portrait.[1] *JWT*

[1]Sarah Cash, *American Paintings from the Manoogian Collection.* [exh. cat., National Gallery of Art] (Washington D.C., 1989), 70, no. 25.

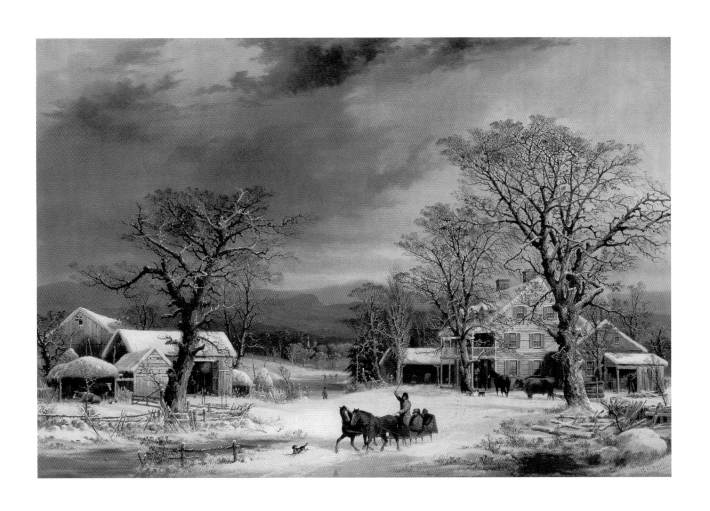

Thomas Eakins
1844-1916
The Art Student (Portrait of an Artist),
c. 1890
Oil on canvas, 42 x 32 inches (106.7 x 81.3 cm)

James Wright was one of Eakins' students at the Art Students League in Philadelphia (established by Eakins' loyal students after he was dismissed from his teaching position at the Pennsylvania Academy of the Fine Arts in 1886). Like most of his portraits, it depicts someone Eakins knew. Like most of them the depiction was unsparingly truthful (as in Wright's scarred complexion), and it was initiated by Eakins, not by the sitter.

Because of the close relationship of artist to sitter, and because Eakins' sitters, like Wright, are often reflective or introspective, Eakins' portraits appear to be psychologically probing. Yet beginning about 1890 Eakins seems to have understood the purpose of his portraits rather differently. For instance, the title of this portrait, *The Art Student*, refers not to the individual but to the professional type he (or she) represented.

At the end of his life Eakins was asked his opinion on the present and future condition of American art. In the most memorable part of his answer he said: "American art students and painters [should] study their own country and portray its life and types."[1] This was not empty rhetoric, but a description of the artistic program that Eakins himself had followed for about a quarter of a century, beginning with typological portraits like that of James Wright.

Eakins scientific interests—his careful studies of anatomy, perspective, and motion, to which he applied himself with mathematical precision and scientific rigor—have often been discussed. The study of American "life and types" that he undertook in his late works is similarly scien-tific, but in the nature and using the methods—of which typology was an important one—of the new social sciences of sociology and anthropology. *NC*

[1] Quoted in Lloyd Goodrich, *Thomas Eakins*, 2 vols. (Washington, 1982), 2:269.

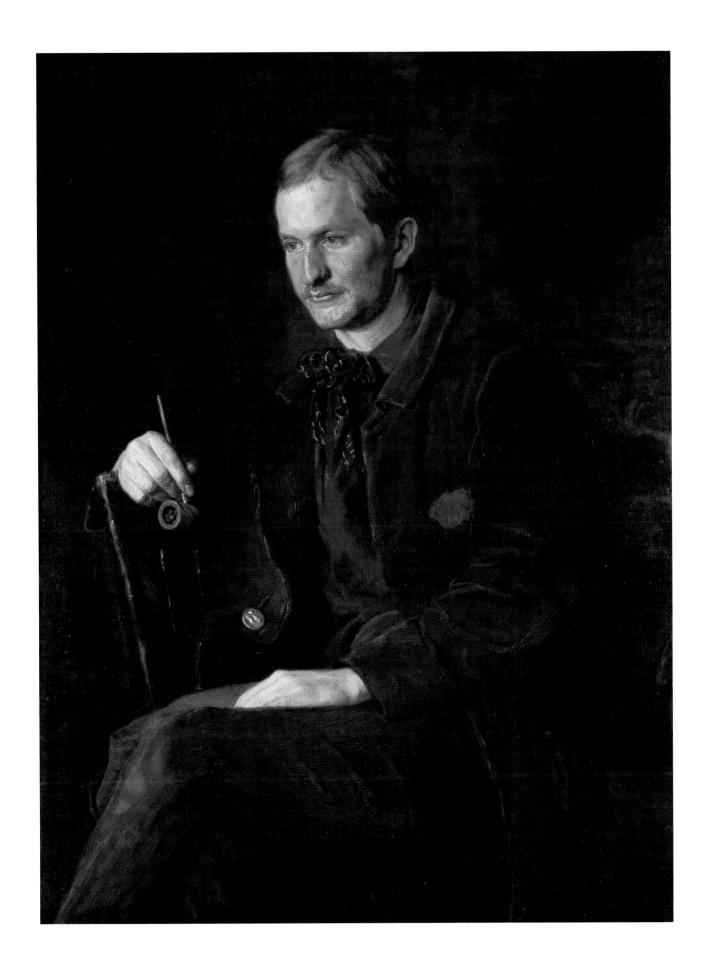

John F. Francis
1808-1886
Cakes, Wine, and Fruit, 1852
Oil on canvas, 20 x 24 inches (55.9 x 102.2 cm)

Francis completed *Cakes, Wine, and Fruit* shortly after he abandoned portraiture in preference for food still lifes. This particular canvas represents the luscious abundance of a late autumn dessert table in both the fruits and nuts scattered on the white linen cloth as well as the walnuts, chestnuts, oranges, and raisins still on the vine. They are accompanied by cookies, two iced cakes, and bottles of champagne and sherry, both perfect dessert wines.

Francis displayed his powerful, illusionistic techniques in his depiction of the ceramic pieces and glassware containing three different shades of liquid: water in the tumbler, champagne in tall flutes, and sherry in small wine glasses. Francis captured the particularly reflective and translucent qualities of these glasses. The light grazes the tops of each of them, growing more intense as it moves toward the cake placed on the compote. The bottles in the center of the composition reflect the white light, and the foil on the neck of the champagne bottle becomes the focal point.

While the glasses are most likely of European origin, the ceramic pieces prominent in the composition are probably American. Francis spent most of his life in and around Philadelphia and would have been familiar with the local porcelain manufacturer William Tucker. The pitcher, compote, and dish are reminiscent of the work of his factory and could easily have been obtained for props. Tucker porcelain was highly prized in the mid-nineteenth century and would certainly have been recognized by his patrons. *JWT*

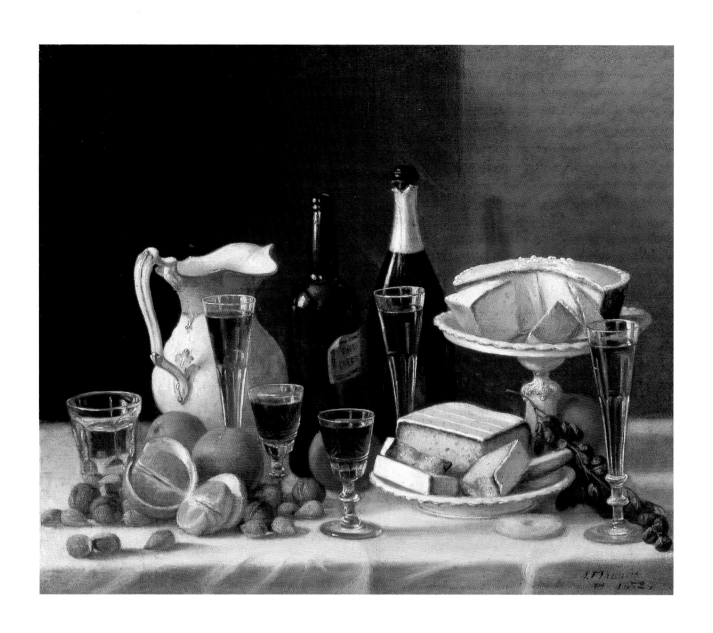

18

Frederick Carl Frieseke
1874-1939

Two Ladies in a Boat, c. 1910
Oil on canvas, 26 x 32 inches (66 x 81.3cm)

Born in Michigan, Frederick Frieseke spent his entire artistic life in France, living for fifteen years in "that haven of artists,"[1] the village of Giverny. Frieseke was a latecomer to Giverny. By the time of his first visit in 1900, the magnetic presence of its most famous artistic resident, Claude Monet, had already attracted three generations of admiring visitors to Giverny.[2] Frieseke was also, like others of his generation, a late-comer to Impressionism. By the first decade of the twentieth century the Impressionist style of artists like Frieseke was no longer seen as an invention derived or deduced from direct experiences of nature, as the original formulation of Impressionism had been. It was regarded, despite Frieseke's claim that he painted what he saw before him and tried "as much as possible to make a mirror of the canvas,"[3] a derivation from what were familiar, well-established, and even, as many artists (including those of Frieseke's generation) were coming to feel, somewhat worn out forms and practices.

Frieseke's art was unapologetically hermetic, and, given the momentous times in which he lived (through one world war to the beginning of another, and through successive assaults of radical artistic modernism), astonishingly unperturbed by the outside world. In 1914, on the eve of the First World War, he said, of paintings like *Two Ladies in a Boat,* "It is sunshine, flowers in sunshine, girls in sunshine, the nude in sunshine, which I have principally been interested in...," and the war did nothing to change that even though his house in Giverny was shaken by cannon fire and refugees passed by his door. "I am not at all interested in politics nor in what goes on in the world," he said, "and I seldom look at the daily papers." As for artistic modernism, he thought Matisse was a "faker" who only painted "to make a sensation." [4]

Official honors—medals and prizes from institutions in many countries—were lavished on Frieseke. However, when his work was shown in the Macbeth Gallery in New York in 1932 not one painting sold. In the depths of the Great Depression and with the ominous clouds of war and fascism rapidly gathering, something more was wanted in art than Frieseke's girls in sunshine. *NC*

[1]Clara MacChesney, "Frederick Carl Frieseke: His Work and Suggestions for Painting from Nature," *Arts and Decoration* 3 (November 1912), 14.

[2]See William H. Gerdts, *Monet's Giverny: An Impressionist Colony* (New York, 1993).

[3]Quoted in Allen S. Weller, "Frederick Carl Frieseke: The Opinions of an American Impressionist," *Art Journal* 28 (Winter 1968-1969), 162.

[4]Weller 162, 163.

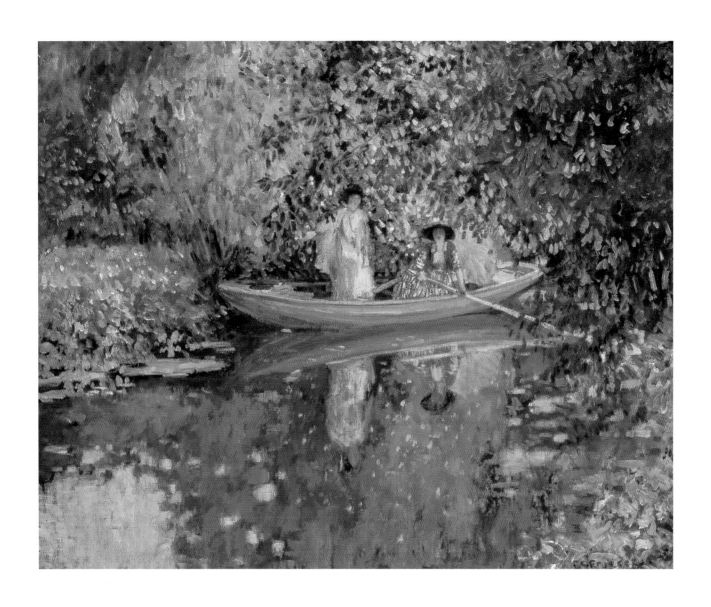

19

Daniel Garber
1880-1958
Mending, 1918
Oil on canvas, 46 x 42 inches (116.8 x 106.7 cm)

Garber painted *Mending* in 1918 while at his summer residence near Lumberville, Pennsylvania. In 1907 his father-in-law had purchased land in Bucks County, Pennsylvania, that included parts of Lumberville. The property was composed of a house, barn, and several outbuildings that had belonged to an old mill complex. This purchase hastened Garber's return from a stay in Paris. He was so fond of "Cuttalossa," as he called it, that by 1915 he was spending several days there each week during the winter; in the 1920s it became his year-round home. Garber wrote, "I am in a wilderness—without telephone connections. Nearest R.R. station and telegraph office are in the state of New Jersey... This wilderness is wonderful just now. Quiet in times for any of its many short-comings."[1] Garber reveled in the time spent there with his family, and the area provided ample subject matter for his many paintings of trees covered in moss and vines, set against a backdrop of hills and mountains.

In *Mending*, Garber expanded the scope of his typical landscapes with the addition of a figure. He placed a woman in profile, almost in silhouette, on a porch with a wall of willow leaves in the background. The sitter was probably his wife, May, posed seated on a balcony of his studio.

The figure glows from the sun blazing through the yellow-green leaves of the willow tree. Garber's landscapes were often compared to tapestries. Here, the modulations of color in the leaves and branches make the canvas appear as if it had been woven. This effect was achieved by its flatness and by the dry application of pigment, an aspect of Garber's technique for which he received great praise from his contemporaries. *JWT*

[1]Daniel Garber, Letter to Clyde Burroughs, April 15, 1918. Curatorial files, Department of American Art, The Detroit Institute of Arts.

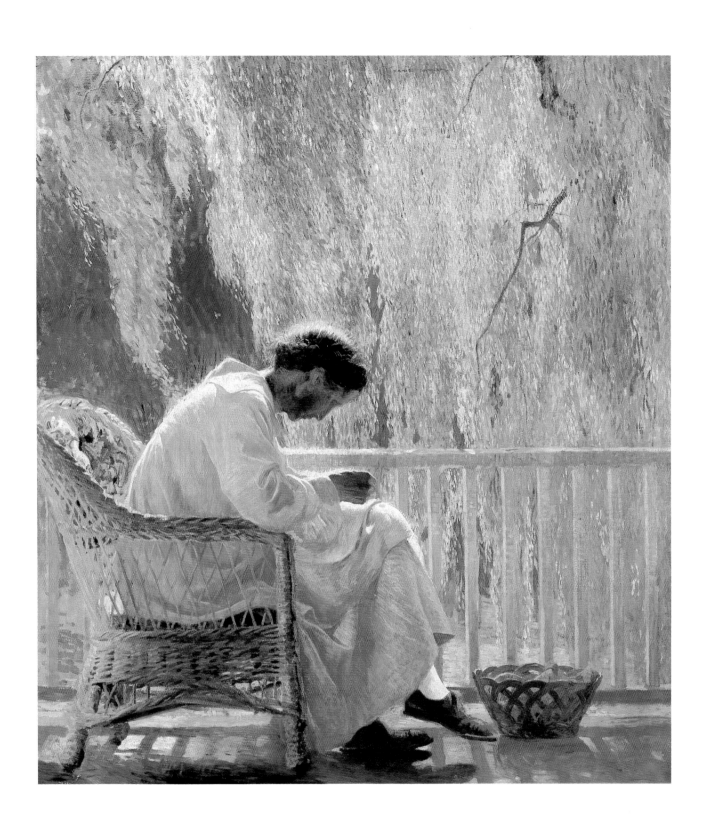

Sanford Robinson Gifford
1823-1880
An Indian Summer's Day on Claverack Creek, 1878-80
Oil on canvas, 30 x 24 inches (76.2 x 60.9 cm)

The most distinctive feature of Gifford's mature paintings, of which *An Indian Summer's Day on Claverack Creek* is a particularly beautiful example, is the mood he established through color and luminous atmosphere. In his mature work, Gifford favored warm hues and concentrated not so much on light's effect on natural objects as on the "veil" or medium through which they are seen. These paintings reflect, in Gifford's own terms, the mystery and poetry he so admired in the work of the English painter J. M. W. Turner.

In *Claverack Creek,* Gifford adopted the type of composition often favored by Asher B. Durand—intimately sized and vertical—as opposed to the grandiose and horizontal format favored by Cole and Church. Brilliant impastos of paint light the autumn leaves of the foreground trees, which seem to form a Gothic arch in a woodland cathedral, symbolizing the natural world's affinity with the spiritual. The background disappears in that veil of luminous light that so delighted Gifford's contemporaries.

According to Ila Weiss, the scene commemorates an outing in the countryside near Hudson, New York, in the autumn of 1876 with Mary Canfield, the widow of an old friend. Gifford and his companion are pictured with a rowboat; he fusses with it, while she stands behind him. The cathedral-like setting and the idyllic mood suggest the feelings that resulted in the couple's secret marriage the following summer, when he was nearing his fifty-fourth birthday and she was fifty-two.[1] *NRS*

[1]Weiss, Ila. "Reflections on Gifford's Art." In *Sanford R. Gifford.* [exh. cat. Alexander Gallery] (New York, 1986), cat. No. 43.

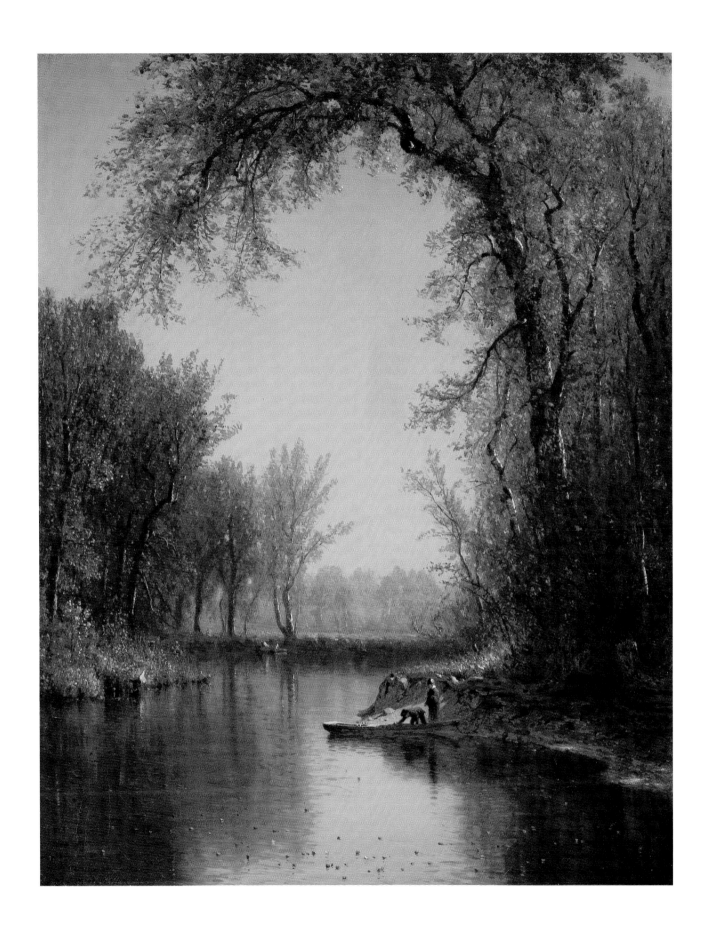

William Glackens
1870-1938
Little May Day Procession, c. 1905
Oil on canvas, 25 x 30 inches (63.5 x 76.2 cm)

Little May Day Procession is one of several views of New York's Central Park that Glackens painted around 1905. It forms a pair with *May Day, Central Park* (c. 1905, The Fine Arts Museums of San Francisco), one painting showing the approach of a May Day procession, the other its rowdy aftermath. The urban park was a favorite subject of Glackens' friend and colleague Maurice Prendergast,[1] and would have been familiar to both artists from examples by Parisian painters of modern life such as Édouard Manet. Glackens also painted the Luxembourg Gardens in Paris during his 1906 visit, in works that are remarkably similar in composition and mood to his Central Park views.[2]

The first day of May was observed in turn-of-the-century New York as both the traditional moving day and an international labor holiday, but it was not always the date for organized May Day celebrations. These were held on an appointed day (usually Saturday) early in the month, when springlike weather could be assured. As Glackens' painting describes, certain festivities were reserved for children: "[It] was in Central Park that the biggest carnival was had. At Fifth avenue and Fifty-ninth street the parade of millionaires in their handsome coaches swept past one hundred little girls and boys marching toward the croquet grounds for a day of fun...The park fairly bristled with youngsters. They came from far and from near...Presently the grass was so strewn with white frocks that at a little distance it looked as if household linen laid out to bleach had suddenly taken to skipping about."[3] Glackens described this festive event with the quick, facile lines that he commanded as an illustrator, and in the dark, rich colors that he learned from Robert Henri and Manet. Everett Shinn noted the connection between Glackens' training as an illustrator and his style as a painter when he praised the "super achievement" of paintings such as this one in which "All color is mingled

in his mighty draughtsmanship."[4] The vivid, energetic paint handling and Glackens' sure execution yield an apt metaphor for the exuberant celebration of May Day in Central Park. *SM*

[1]Prendergast painted several watercolors of Central Park, including a May Day, around 1901; see Patterson Sims, *Maurice B. Prendergast: A Concentration of Works from the Permanent Collection* [exh. cat., Whitney Museum of American Art] (New York, 1980), 15-16.

[2]Glackens' paintings of the Luxembourg Gardens are in The Corcoran Gallery of Art, Washington, and The Wichita Art Museum, Kansas.

[3]"May Queens Ruled Tiny Subjects in City Parks," *The World*, 8 May 1904; "Happy Youngsters Celebrate May Day," *The World*, 2 May 1903.

[4]Everett Shinn, "Recollections of the Eight," in *The Eight* [exh. cat., The Brooklyn Museum] (Brooklyn, 1943), 19.

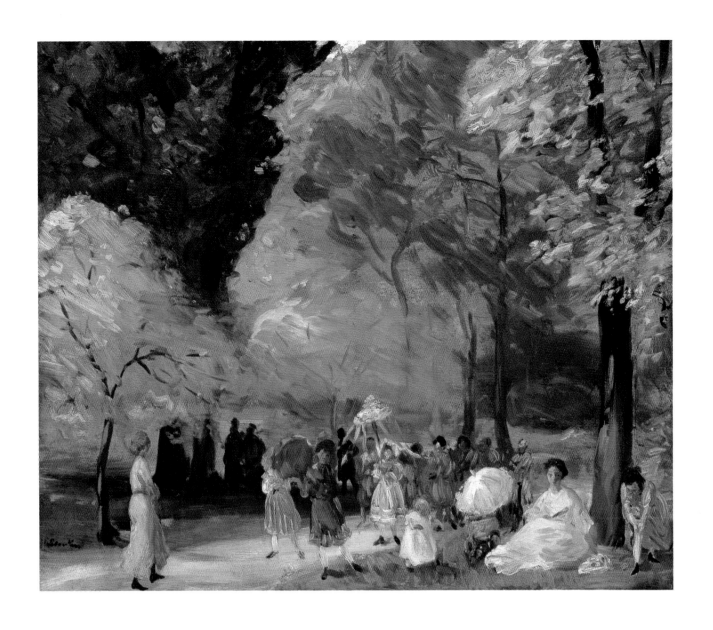

22

William Michael Harnett

1848-1892

The Social Club, 1879

Oil on canvas, 13½ x 20¼ inches (34.3 x 51.4 cm)

To a society obsessed with the idea of amassing collections of household objects that varied in interest and worth, William Harnett provided the perfect pictorial answer. He supplied the type of canvas that was well accepted in the male-dominated arenas, the office, club, and tavern. The compositions, especially those of his early years, consist of collectable objects, including beer steins, books, and pipes. *The Social Club* provides a key example of such a composition. Consisting of a collection of pipes with tobacco and a cigar box, Harnett arranged them as if they were a floral bouquet. He placed the four used pipes and four struck matches in a manner to suggest that a group of four men had just left after "casually" placing their pipes on the marble shelf. Stylistically, *The Social Club* is representative of Harnett's early period, employing humble models (once he moved to Europe his models became more elaborate). Painted in 1879, *The Social Club* was Harnett's sole representation that year at the Pennsylvania Academy of the Fine Arts in Philadelphia.

Although the painting was sold, neither it nor Harnett received positive reviews. An anonymous critic considered his work to be not much more than a curiosity, and compared the trompe l'oeil composition to the work of a sign painter. The writer went further to say that great artists only use these devices as play and never as serious work.[1] This attitude was consistent with many contemporary critics, especially during the early years of Harnett's career. In any event, Harnett's work sold well enough to send him to Europe in 1880. *JWT*

[1]Alfred Frankenstein, *After the Hunt: William Harnett and other America Still Life Painters 1870-1900* (Berkeley and Los Angeles, 1953), 50.

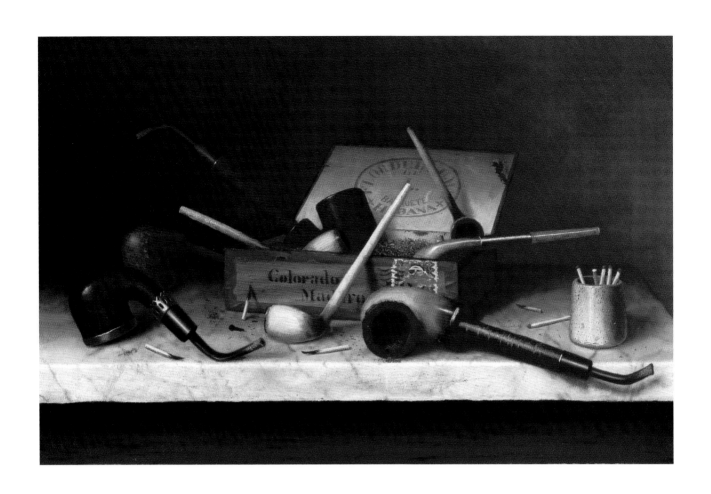

23

William Stanley Haseltine
1835-1900
*Summer Afternoon,
Nahant, Massachusetts,* 1864
Oil on canvas, 31¼ x 56½ inches (79.4 x 143.5 cm)

William Stanley Haseltine studied art at the academy in Düsseldorf, Germany from 1855 to 1859, and after 1866 he lived in Europe, mostly in Rome. His work in America was confined to the period 1859 to 1866 and to the subject, virtually to the exclusion of any other, of the New England seacoast, first in Maine, then at Narragansett Bay, Rhode Island, and, in 1864, at Nahant, Massachusetts.

Nahant, near Boston, was a popular summer resort. It was not society at Nahant that interested Haseltine, however, but, as it had done elsewhere along the coast, the rocky shore. A critic who admired his "capital rock drawing" saw what most drew Haseltine to the subject when he wrote, "he takes an interest in the formative laws no less than the external appearance of scenery."[1] The "formative laws" the critic had in mind, of course, were those of geology. Many nineteenth-century artists worked in the climate of scientific discoveries that radically and often disturbingly revised conceptions of the age and formation of the earth and of mankind. But Haseltine's paintings showed the influence of science more clearly than most: "they speak to the eye of science of a volcanic birth and the antiquity of man," a contemporary historian of American art wrote.[2] The rocks of Nahant, what is more, spoke particularly to the eye of a scientist, one who was popularly regarded as the greatest scientific figure of his age: Louis Agassiz, professor of zoology and geology at Harvard (of whom Haseltine would have known; he was a Harvard graduate, class of 1854, and a member of the Natural History Club presided over by Agassiz's son Alexander). At Nahant, Agassiz found special support for his geologic theories; "Agassiz pronounces the rocks of Nahant to be the oldest on the globe, and that they are of volcanic origin," a visitor to Haseltine's studio wrote of his Nahant pictures, adding, "Mr. Haseltine fully conveys their character in his pictures, and no one who has wandered over those huge masses of rough red rock, and

watched the waves breaking against them, could fail to locate, from his studies, the very spot he has delineated."[3]

To the modern eye the abstract form of Haseltine's rocks, not their geology, is the most appealing aspect of his paintings. *NC*

[1]"Fine Arts. The Brooklyn Artist's Reception," *New York Evening Post,* 5 March 1863.

[2]Henry T. Tuckerman, *Book of the Artists* (New York, 1867), 557.

[3]"Among the Studios," *Watson's Weekly Art Journal* 1 (8 October 1864), 372.

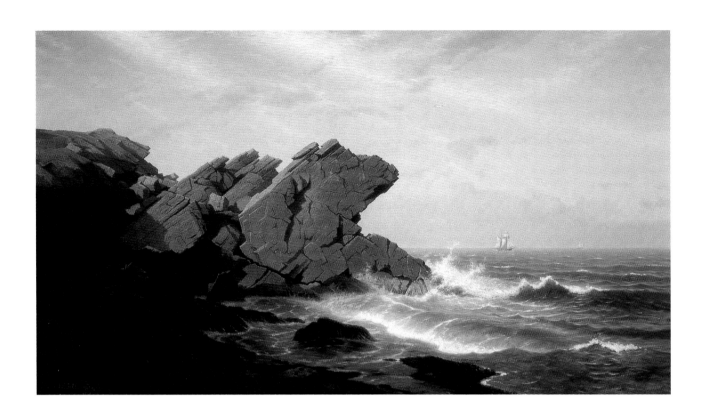

24
Childe Hassam
1859-1935
County Fair, New England, 1890
Oil on canvas, 24¼ x 20⅛ inches (61.6 x 50.8 cm)

This joyous scene was painted shortly after Hassam's return from a three-year stay in Paris, where he first truly embraced Impressionism. As scholars have often noted, many of Hassam's most important New York compositions were created during this early period. That observation might be applied to subjects outside New York as well. It is not known in which New England town Hassam painted this autumn festival, but its lively brushwork and sparkling color are typical of much of his imagery during this time. Of the painting, one contemporary critic wrote, "It is New England to the core, and the pale yet keen light is that of the season and latitude."[1]

Throughout his career, Hassam succeeded in capturing the unique flavor of a particular locale, be it an obscure urban neighborhood or a small country village. Though he spent most of his professional life in New York City, his ties to New England, where his ancestors had settled in the seventeenth century, remained strong. He was especially attracted to the region's historic buildings, which he came to view as symbols of the national heritage. Commenting on his childhood in Massachusetts, Hassam referred to the white churches as "masterpieces of architecture; and the white church on Meeting House Hill as I look back on it was no exception...All unconsciously I as a very young boy looked at this New England church and without knowing it appreciated partly its great beauty as it stood there then against one of our radiant North American clear blue skies."[2] The festive crowd of *County Fair* is massed in front of just such a building. A palette of red, white, and blue underscores the nationalistic implications of the scene, while the banners decorating the facade, the flags among the crowd, and especially the American flag isolated against the clear blue sky predict the series of flag paintings Hassam would begin in 1906.
NRS

[1]Ultich W. Hiesinger, *Childe Hassam: American Impressionist.* [exh. cat. Jordan-Volpe Gallery] (New York, 1994), 76.

[2]Adeline Adams, *Childe Hassam.* New York, 1938, 90.

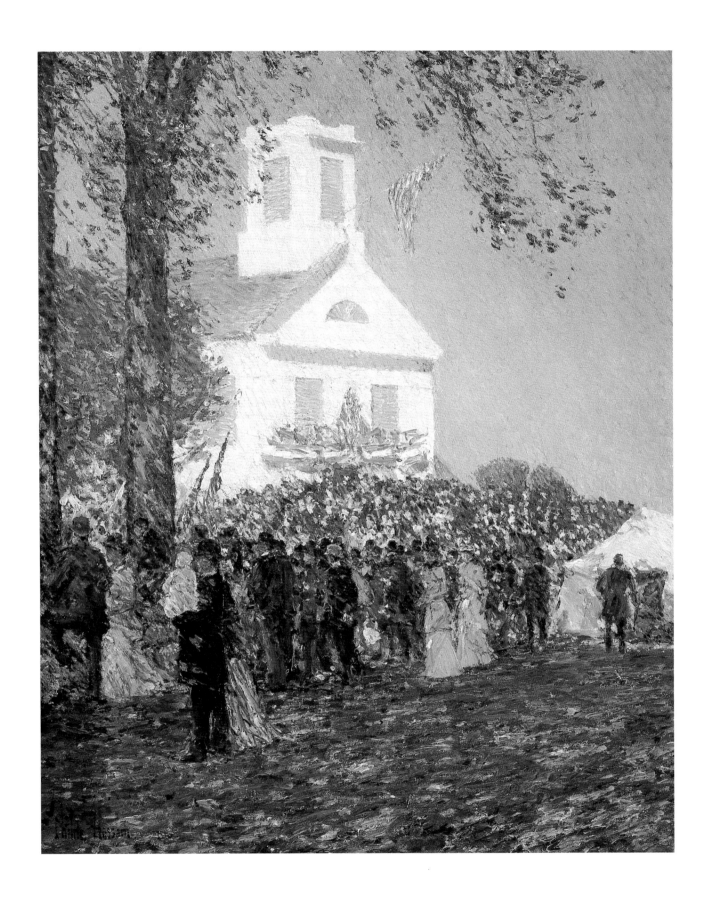

25

Martin Johnson Heade
1819-1904
Magnolias on a Blue Velvet Cloth,
c. 1885-1895

Oil on canvas, 15⅛ x 24¼ inches (38.4 x 61.6 cm)

Martin Johnson Heade was the only major American artist of the nineteenth century to make important contributions both in landscape and still life painting.[1] Virtually all of his still lifes were floral pieces, starting with elegantly simple pictures of flowers in vases in the early 1860s and culminating in the 1880s and 1890s in a glorious series of roses, magnolias, and other flowers spread on velvet cloths. Although Heade continued painting landscapes until the end of his life, the flower pictures—and especially the magnolia paintings—are considered the strongest of his late work.[2]

Only one of the dozen or so known pictures of giant magnolias is dated (*Magnolia Grandiflora,* 1888, collection of Jo Ann and Julian Ganz, Jr., Los Angeles), but most were doubtless executed about the same time. The paintings in the series vary in size, in the number of flowers depicted, and in the color of the velvet, but the most successful examples generally show two or three blossoms against a blue background. Heade was obviously intrigued by the play of the shapes of leaves, petals, and folds of cloth, and infused the paintings with a sinuous rhythm of lines formed by the curving edges of flowers and leaves. But he was apparently also fascinated by contrasts of color, texture, and tone, because the brilliantly lit yet softly glowing petals stand out sharply from the dark green leaves, which shine with almost metallic brilliance.

Heade's magnolia paintings are among the most original still lifes of the nineteenth century, having no obvious precedents in either American or European art.[3] It is not clear whether the artist intended for them to carry specific meaning, even though his orchid and hummingbird pictures are often undeniably charged with sexual connotations. Nevertheless, the sensuous tones, curving contours, and beautiful opulence of

the magnolia paintings are deeply suggestive, and bring to mind, as John I. H. Baur once observed, "odalisques on a couch." [4]
FK

[1]Theodore E. Stebbins, Jr., *The Life and Works of Martin Johnson Heade* (New Haven and London, 1975), 111.

[2]Stebbins, *Heade,* 166.

[3]Stebbins, *Heade,* 166.

[4]Commemorative Exhibition: *Paintings by Martin Johnson Heade and F. H. Lane from the Karolik Collection in the Museum of Fine Arts, Boston* (New York, 1954), quoted in Stebbins, *Heade,* 176.

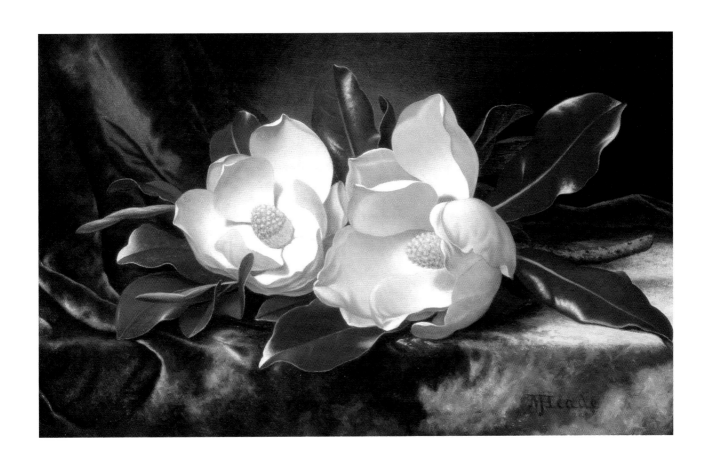

26

Martin Johnson Heade
1819-1904
Cattleya Orchid, Two Hummingbirds, and a Beetle, n.d.
Oil on canvas, 14¼ x 22¼ inches (36.2 x 56.5 cm)

Martin Johnson Heade's paintings of orchids and hummingbirds are so extraordinarily beautiful in color and design, so exceptionally inventive and imaginative, that it is something of a surprise to know that their origins lay squarely in nineteenth century descriptive, taxonomic science.

In the 1860s, Heade, who was "since early boyhood," as he said, "almost a monomaniac" on hummingbirds,[1] conceived the idea of writing and illustrating a book on the subject titled, *The Gems of Brazil*—so titled, perhaps, because Heade's friend, the naturalist, the Reverend James C. Fletcher, described hummingbirds in his book, *Brazil and the Brazilians* as "little winged gems."

Heade's projected *Gems of Brazil* was part of a long tradition of ornithological publications. The most famous and lavishly ambitious product of that tradition was John James Audubon's *Birds of America* (1827-1838), but Heade's work owed more to another, more recent publication specifically on hummingbirds, John Gould's *Monograph of the Trochildae* (1849-1861). Heade knew he could not outdo Gould's work as a scientific text. What he could contribute was knowledge, which Gould, who never visited South America and worked from specimens, did not have. Heade visited Brazil for about a year in 1863 and was able to base his illustrations not only on firsthand observation of live hummingbirds but of their natural habitat as well.

Heade made twenty paintings (of which sixteen survive, now in the Manoogian Collection) that he planned to have reproduced by chromolithography as illustrations for *The Gems of Brazil*. The few that were made proved to be unable to capture the colors and landscape settings—the very things, of course, most essential and special to Heade's text—and the publication was abandoned. But Heade did not abandon the subject. Far from it, beginning in 1871 and continuing virtually until his death about thirty years later, he made a series of hummingbirds with orchids in tropical landscape settings that have become both his signature paintings and singular—and singularly beautiful—contributions to American art. *NC*

[1]Quoted in Theodore E. Stebbins, Jr., *The Life and Works of Martin Johnson Heade* (New Haven and London, 1975), 129.

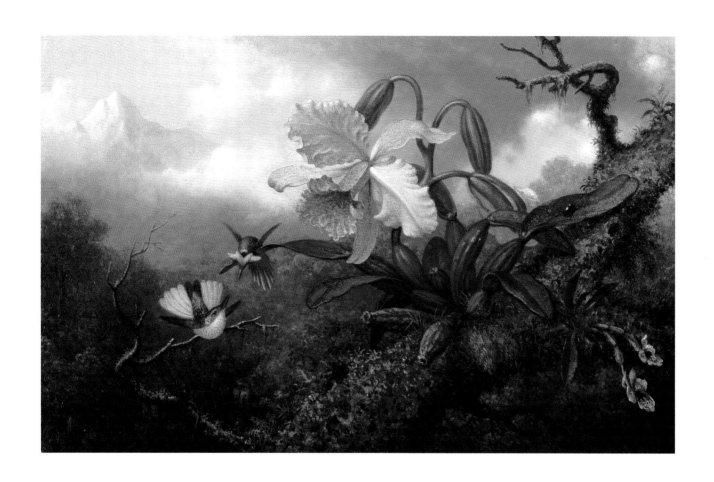

George Inness
1825-1894
Overlook Mountain in the Catskills, 1868
Oil on canvas, 20¼ x 30 inches (51.4 x 76.2 cm)

The Catskill Mountains of New York were sacred territory for American landscape painters of the first half of the nineteenth century, the place where, to a remarkable extent, the conceptual and stylistic canons of a national landscape were formulated, chiefly by Thomas Cole. Although he was born nearby, in Newburgh, New York, George Inness' vision was formed elsewhere—in Italy and, most of all, in France—and was very far from canonical. By the 1860s his landscape style was unmistakably and deliberately different in appearance and intention from the practices and principles of "official" American landscape painting. "Mr. Inness has long held the opinion," it was said in 1863, "that...the highest beauty and truest value of the landscape painting are in the sentiment and feeling which flow from the mind and heart of the artist."[1] The primary visible vehicle of Inness subjective, self-expressive landscape—which, as a sympathetic critic put it, "uses natures forms simply as language to express thought"[2] —was active and suggestive brush-work: "rough" and "rugged" handling, "grand, hasty strokes of the brush, nervous force of execution, and great sprawling marks of the brush."[3] *Overlook Mountain in the Catskills* is, in its quality and clarity of purpose, a particu-larly fine example of Inness' interpretive landscape style, the projection upon natural fact of the fiery "energy" and "sensitive nervous organization" of his personality.[4] *NC*

[1] *The Sign of Promise* (New York, 1863), unpaginated.

[2] *The Sign of Promise.*

[3] "Art Gossip," *Cosmopolitan Art Journal* 4 (December 1860), 183; *New York Evening Post,* 30 March 1866; *New York Commercial Advertiser,* 22 May 1862; H. "When is an Artist True to Himself?" *Boston Evening Transcript,* 19 February 1862.

[4] Mrs. Conant, "George Inness," *The Independent* 27 (27 December 1860).

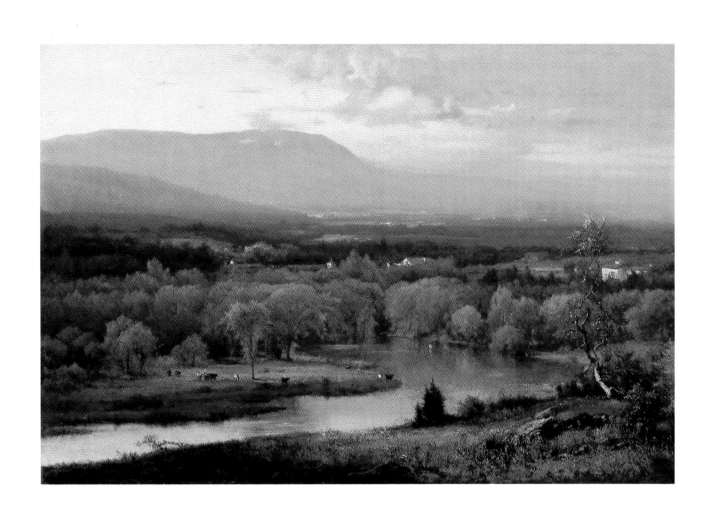

28

Ernest Lawson
1873-1939
Harlem River, c. 1913-1915
Oil on canvas, 40⅛ x 50 inches (101.9 x 127 cm)

In 1898 Ernest Lawson established a studio in Washington Heights in upper Manhattan. From there he painted the Harlem River scenes that are the staple of his work. Like Claude Monet, who painted series of works of the same subject— haystacks, Rouen Cathedral, poplars—in different conditions of light and weather, the Harlem River provided Lawson with a similar subject of study. He chose the area around High Bridge to examine changes of time and season. *Harlem River* captures the scene on an early spring morning, when the mist is beginning to burn off and afford a clear view of the opposite shore.

Lawson almost sculpted his paintings, using his brush, palette knife, and thumb to create a plastic surface; *Harlem River* exemplifies this technique. The built-up pigment forms a smooth plastic base upon which Lawson lightly sketched the skyline to create the hazy effect he wanted. He then depicted the river with thick paint, culminating in the small tugboat that actually projects from the surface of the canvas.

"Lawson's art is realistic," a contemporary wrote, "but he abhors the sordid and ugly (so many moderns wrongly think this is synonymous with character). He paints the prosaic but seen through the eyes of an artist not through the lens of a camera."[1] *JWT*

[1] A. E. Gallatin, "Ernest Lawson," *International Studio* 59 (July, 1916), xv.

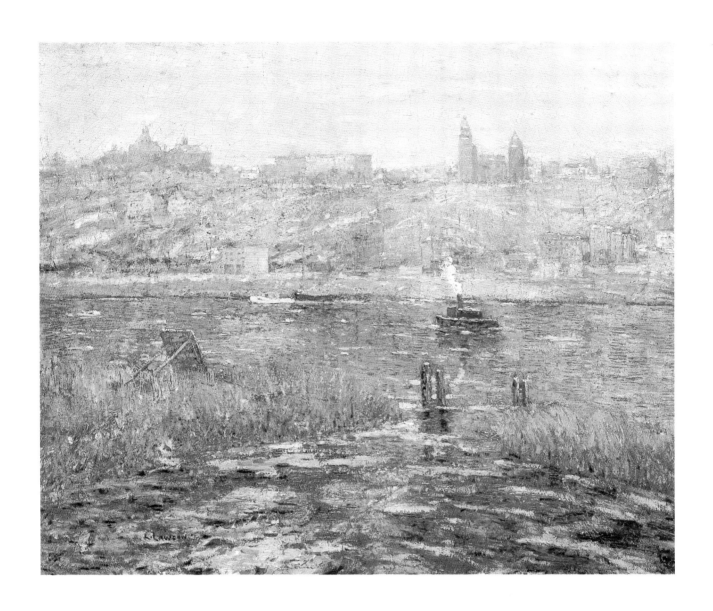

29

Willard Leroy Metcalf
1858-1925
The Poppy Garden, 1905
Oil on canvas, 24 x 24 inches (61.3 x 61.3 cm)

In 1905, drawn by his friendship with Childe Hassam and the colony of artists in residence at Miss Florence Griswold's boardinghouse, Metcalf spent the first of several summers in Old Lyme, Connecticut. In this beautiful New England village, Metcalf, fresh from the success of his first one-man show in New York, approached his craft with particular enthusiasm. His joyful mood is revealed in the flowers that appear in profusion in a number of canvases, the best known of which is *The Poppy Garden.* It made its debut the following spring in the "Eighth Exhibition of the Ten Americans" in New York. Critics were impressed with the lyrical lightness and charm of Metcalf's Old Lyme subjects and in their reviews of this and a slightly earlier exhibition pronounced them his best work to date. A painting of "a capital river view with hedges, some billowy laurel bushes, and a gorgeous poppy garden" was one of the works singled out for praise.[1]

Metcalf had begun to incorporate the Impressionist techniques of diffused light and broken color into his landscapes as early as 1895, but he maintained a meticulous definition of form and never completely abandoned local color. This summer scene, with its high-key red-and-green palette, is one of his most animated improvisations on nature, the bright poppies and other blooms appearing as a magnificent blaze of color against the foil of the blue-gray water, the sun-bathed vista, and the pale-blue sky.

Although gardens and fields of flowers were a popular subject for American Impressionists, Metcalf's forays into outdoor flower painting were rare. The poppy motif is one made popular by Monet, but a more direct influence may be found in Childe Hassam's informal garden scenes of the 1890s—some of lush beds of poppies offering a distant view of the sea, sky, and islands beyond. At the same time, Metcalf impressed his own temperament on the subject, for *The Poppy Garden* incorporates the square format and the ingratiating mixture of brush work—long and broken in the foreground, smooth in the river and sky—that characterize Metcalf's adaptation of the Impressionist style.
NRS

[1] *Evening Post,* March 16, 1906, Metcalf Correspondence and Papers, Archives of American Art, Smithsonian Institution, Washington, D.C., roll N70/13, frames 505 and 506.

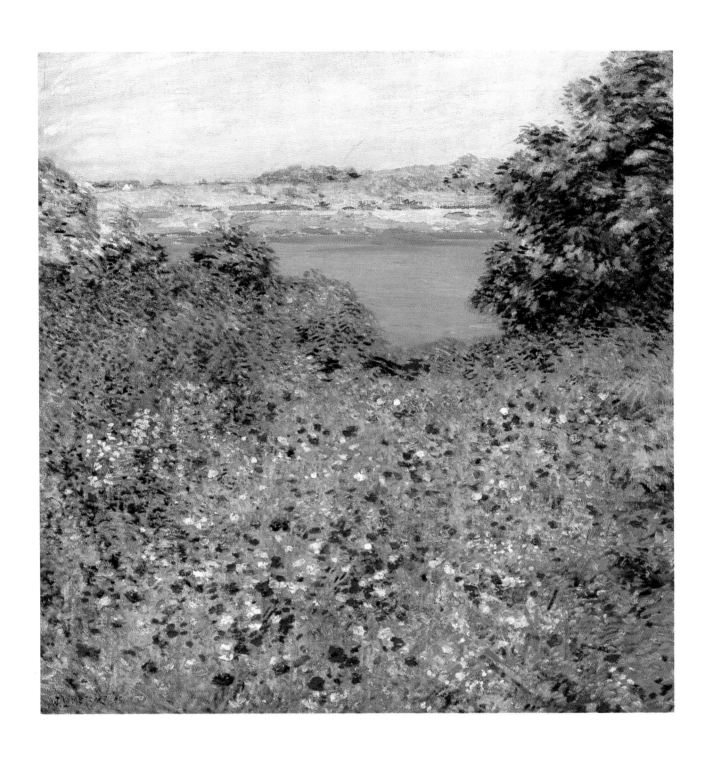

Louis Remy Mignot
1831-1870
Autumn, Lake George, 1862
Oil on canvas, 24¼ x 40 inches (61.6 x 101.6 cm)

The spectacular colors of autumn were a popular subject with the Hudson River School landscape painters. In the scene of Lake George in upstate New York, Mignot rendered the contrast between the vibrant red and yellow leaves and soft blue, sun-drenched sky.

Mignot created scenes of an unspoiled natural paradise, typically including a lone figure walking through the woods. He took some artistic license with this view, for when he visited Lake George in the late nineteenth century it was a popular vacation spot. Such manipulation, however, was common among American landscape painters. As the country, particularly the East, became populated, artists chose their vantage points to avoid signs of encroaching civilization and preserve, if only in paint, vanishing wilderness nature. *JWT*

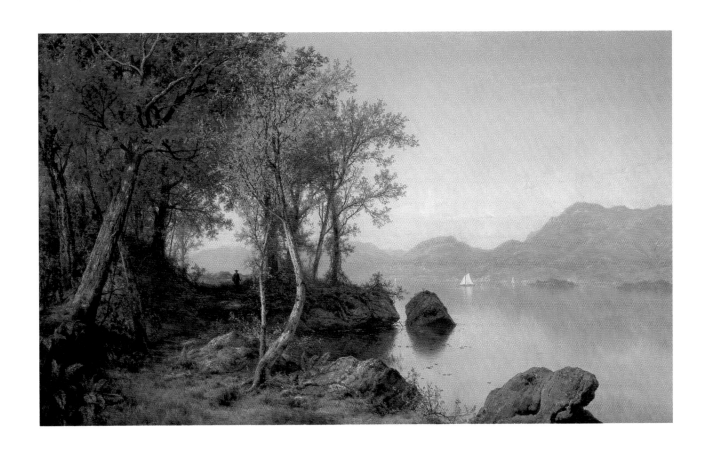

31

Francis Davis Millet
1846-1912
The Window Seat, 1883
Oil on canvas, 24 x 36 inches (51.1 x 76.8 cm)

The Window Seat, in spite of its potentially sentimental subject, is a painting about light—interior and exterior light, light passing through glass and light filtered through muslin, light modeling form and light reflected from forms. Through the windows behind the young woman, in a muslin dress and fichu of the early nineteenth century (and reputedly Millet's wife), streams a cool light that dances off the polished surfaces of the interior—the table with its propped-open book and flowers, the spindle chair on which the woman rests her feet—and glows within the layers of the white curtains.

The Window Seat is one of Millet's earliest English subject pictures. It probably recreates a scene that he first saw in the summer of 1883 while staying with a group of artists and writers connected with the Harper's publishing firm, among them Edwin Austin Abbey, at the White Lion Inn in the Oxfordshire village of Bidford-on-Avon. In the next summer Abbey would discover the Worcestershire village of Broadway and establish his home as the center of a thriving Anglo-American art colony which attracted, among others, John Singer Sargent.

Millet first exhibited *The Window Seat* in London in 1883. One critic wrote that it "evinces a fine sense of the harmonies of white, and light and shade, and solid and semi-lucid forms," and another said, "The lighting is most dexterously managed, and the cleverness of the picture is almost obsessive..."[1] Millet clearly valued the painting. He exhibited it in New York in 1885 and again at the World's Columbian Exposition in Chicago in 1893 where one writer admired it as a simple story simply told.[2] *MS*

[1]Institute of Painters in Oil Colours, *Athenaeum* 2930 (22 December 1883), 822; The Institute, *The Magazine of Art* (1884), 163.

[2]Hubert Howe Bancroft, *The Book of the Fair,* 2 vols. (Chicago, 1893), 2:683.

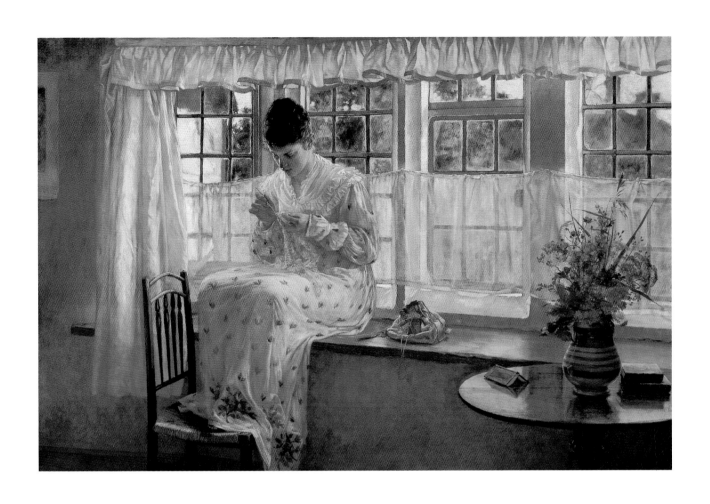

32

Jerome Myers
1867-1940
Recreation Pier, n.d.
Oil on canvas, 25 x 30 inches (63.5 x 76.2 cm)

Although he was born in Petersburg, Virginia, and did not move to New York City until 1886, when he was nineteen (and when he had his first serious artistic training), Jerome Myers dentified himself deeply with New York for the rest of his life. Twenty years before the realist painters of the so-called Ashcan school—John Sloan, William Glackens, George Luks, and Everett Shinn—depicted urban life, and many years after they ceased doing so, Myers made it his subject, particularly the life of the new immigrants, Jewish and Italian, who crowded into the city's lower east side in the late nineteenth century. Myers had a truly profound affection for his subject, which can be too easily seen as sentimental and romantic.

He particularly liked the summers when, overheated and overcrowded, the population took to the streets and the riverfronts for relief, at a time when there was none to be had from air conditioning, and the human drama was more intense and life was led more freely and picturesquely. One of Myers' favorite subjects, where urban life was particularly concentrated and animated—where people listened to music, danced, gossiped, and above all hoped for cooling breezes—were river recreation piers. *NC*

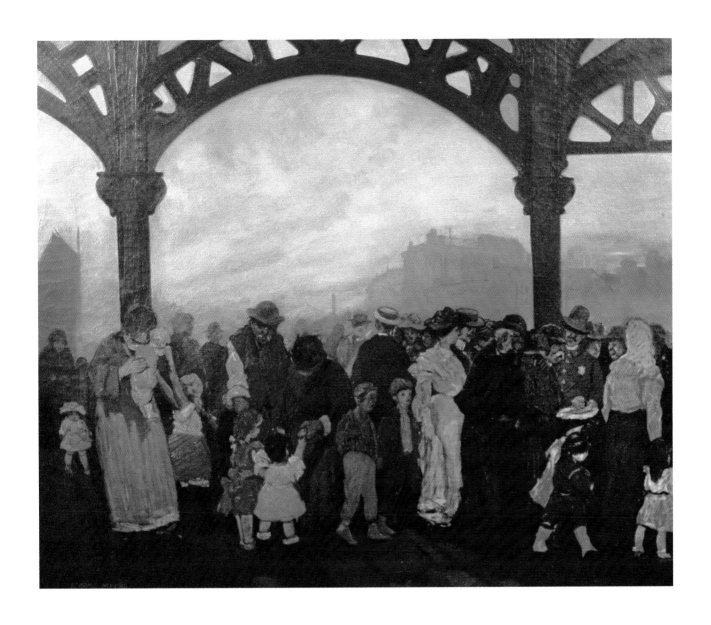

33

Johannes Adam Oertel
1823-1909
Capturing Wild Horses, 1855
Oil on canvas, 40⅛ x 60¼ inches (101.9 x 153 cm)

Capturing Wild Horses is a romantic depiction of the American West. The scene was drawn not from nature but from Oertel's imagination. Unlike his contemporaries, he did not travel to exotic or far-off locations in search of source material for his canvases; indeed, at the time he painted this canvas, Oertel had never left the East Coast. He based his images on the work of artists such as George Catlin, John Mix Stanley, and William Ranney, which he knew from numerous exhibitions in New York and through the plethora of lithographs they produced.

Oertel's understanding of the horse's anatomy is apparent in his depiction of the animal in numerous poses. However, he was unaware of the manner in which a horse moves its legs at a gallop. Oertel's horses exemplified the popular belief that the legs are extended at full gallop. This was found to be inaccurate by studies of motion resulting from the invention of the camera. The flying horses in the lower left corner thus appear a bit fanciful to the twentieth century viewer.

Capturing Wild Horses is not typical of Oertel's work, which consisted primarily of religious imagery. However, what remained constant is a sense of motion, drama, and excitement, evident here in the abundant clouds, the outstretched arm of the rider, and the contorted bodies of the horses. *JWT*

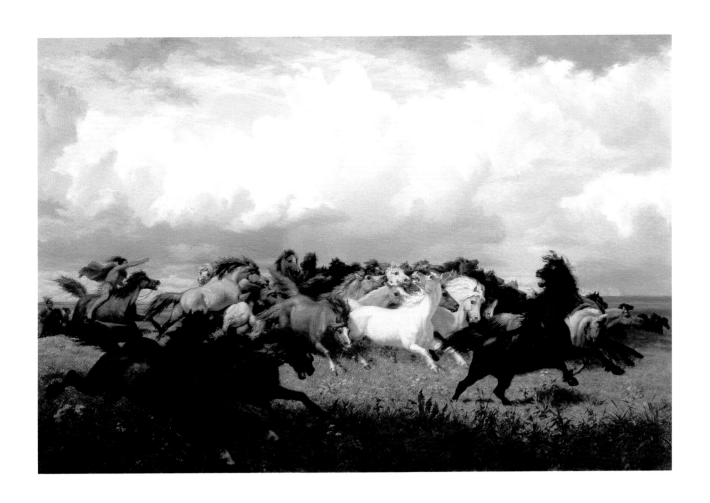

34

William McGregor Paxton
1869-1941
1875, 1914
Oil on canvas, 36 x 29⅛ inches (91.4 x 74 cm)

When Paxton and his wife spent the summer of 1913 in a house built in the 1870s, Paxton was inspired to paint a few works on period themes, one of which was *1875.*[1] In the 1870s, the aesthetic-movement vogue for Japanese art reached America. Paxton has reminded us of this period with a humorous presentation of the meeting of East, represented by the porcelain figurine, and West, portrayed by Paxton's favorite model Lizzie Young. If it were not for the model's posture and the tense positions of her hands, Paxton's clever point would be overshadowed by the exquisite green dress Lizzie is wearing. Paxton had had the dress made in the style of the 1870s and had painted his wife wearing it in another work called *The Green Princess.* When *1875* was exhibited in 1916 at the Art Institute of Chicago, one critic rightly compared the brilliant handling of the gown to the work of Belgian painter Alfred Stevens.[2]

Illustrating Paxton's desire to raise the level of artistic appreciation by giving "the public what it wants, but to make the thing better than the public knows it is,"[3] the nostalgic appeal of *1875* belies the intricacy of its design. The rococo revival chair and table were chosen not as much for historical accuracy, since their style was old-fashioned by the 1870s, as for the compatibility of their forms to the model's position and to the dress. The single strong light source unifies the complicated rhythm of curves and at the same time focuses attention on the whimsical East-West cultural confrontation. *STH*

[1]Ellen Wardwell Lee, *William McGregor Paxton, 1869-1941.* [exh. cat., Indianapolis Museum of Art] (Indianpolis, 1979), 114, 132, 133. *1875* was awarded the Lippincott prize for the best figure painting at the 1915 annual exhibition at the Pennsylvania Academy of Fine Arts.

[2]Indianapolis 1979, 133.

[3]*Boston Herald,* 26 December 1920, as quoted in Indianapolis 1979, 112.

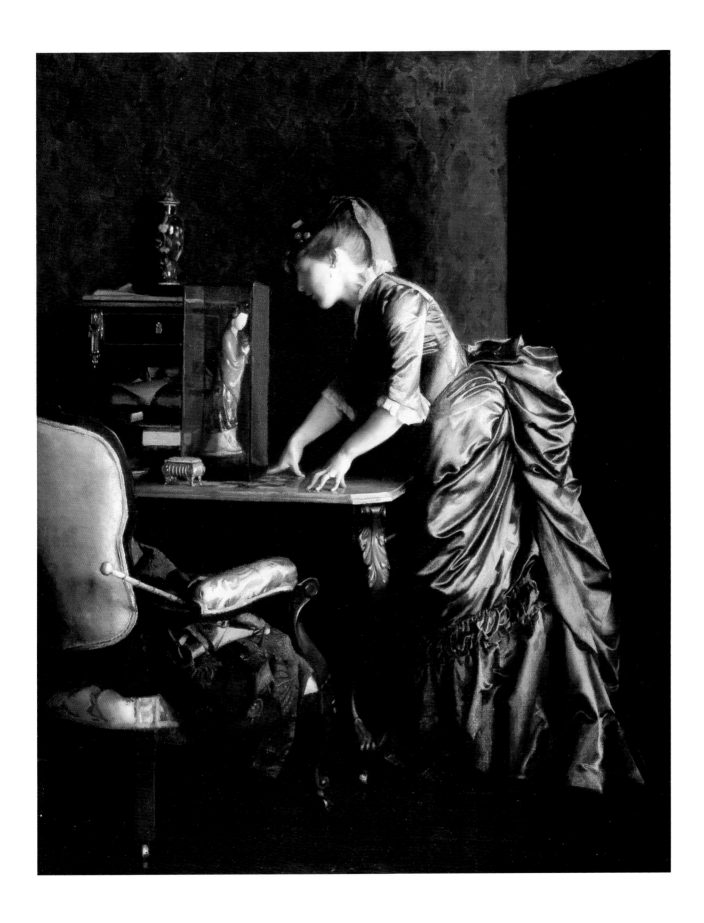

35

Enoch Wood Perry
1831-1915
Mother and Child, 1881
Oil on canvas, 28⅝ x 36¾ inches (72.7 x 93.3 cm)

In 1867, after many years of study and travel in Europe and of painting portraits in such different and disparate places as New Orleans, San Francisco, Hawaii, and Salt Lake City, Perry ettled in New York. There he was part of a group of artists who, in years immediately after the Civil War, devoted themselves to native subjects. The group included Eastman Johnson, E. L. Henry, J. G. Brown, Seymour Guy, Thomas Waterman Wood, and Winslow Homer. Perry became one of the most important members of the group: "Mr. Perry at the present time," a critic wrote in 1875, "occupies a position very nearly at the head of our genre painters."[1] He was also one of its most dedicated members, faithfully exhibiting genre paintings year in and year out to the end of the century, and painting them long after others, like Eastman Johnson and Winslow Homer, had forsaken the cause.

Mother and Child is an example of that dedication. By 1881, when it was painted, it had been superseded in style and subject by the work of such artists, educated abroad, as William Merritt Chase (see cat. 8). But it was also deliberately historicizing in costume, furniture, and architecture, and in that respect reflected the historical revivalism that followed the centennial in 1876.

To the antiquarianism of *Mother and Child* Perry added something else. The light that streams through the window at the right and falls on the nursing mother and child is a wonderful piece of realist observation. But anyone familiar with the iconographic devices of early Netherlandish painting, as Perry seems to have been, must see in it also a piece of disguised symbolism. Light passing through a window symbolized the Virgin's purity and the miracle of her conception, just as the fruit on the table symbolizes the Fall and Christ's redemptory role. This mother and child in an ordinary domestic interior (as the group is usually situated in Netherlandish art) thereby becomes a Holy Mother and Child. *NC*

[1] "Fine Arts," *New York Evening Post* (17 May 1871).

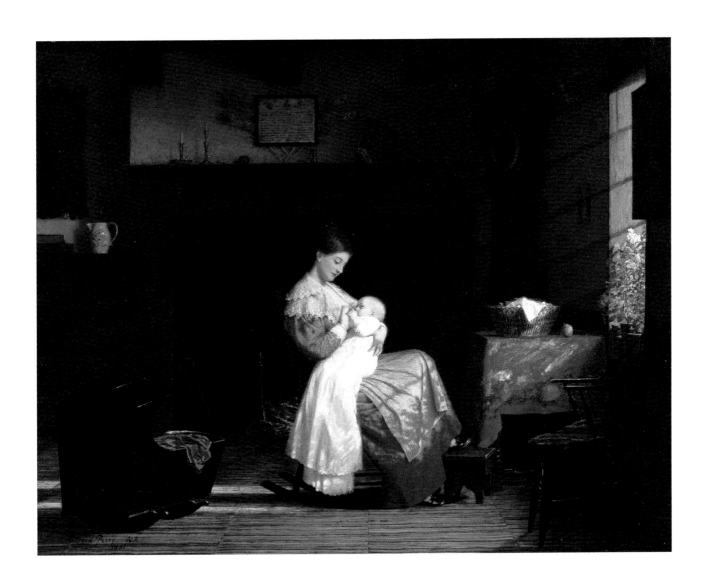

36

John Frederick Peto
1854-1907

*The Writer's Table: A Precarious
Moment,* probably 1890s
Oil on canvas, 27⅛ x 22 inches (68.9 x 55.9 cm)

As a Philadelphian trained at the Pennsylvania
Academy of the Fine Arts, Peto was certainly
familiar with that city's venerable and preemi-
nent tradition of still life painting, beginning
with the works of the Peale family early in the
nineteenth century and continuing to mid-
century with the regularly exhibited examples of
John F. Francis and Severin Roesen. Americans
had variously looked to earlier European prece-
dents in Dutch and Spanish seventeenth-century
painting, and by the end of the nineteenth
century there was also a revival of awareness of
Chardin's still life achievements. Aspects of this
rich tradition find echoes in Peto's sensuous and
sometimes stark tabletop compositions. Perhaps
the most immediate, conditioning influence on
his style was the meticulous technique of his
colleague William Michael Harnett's still life
arrangements of worldly objects and Victorian
bric-a-brac. But after the early association in
Philadelphia, Peto emerged from Harnett's
shadow in mature work such as this, exploiting
much more personally and forcefully rough
textures of paint, strong combinations of color,
and brightly lit forms set against often mysteri-
ous, impenetrable backgrounds. Here the
variations of blues below and orange-reds above
coexist as much in tension as in harmony. Peto
has arranged his objects in a grouping that
similarly seems caught between accident and
contrivance. The eye is initially lulled into
reading the solid and stable geometries of books,
candlestick, inkwell, and mug, only to become
aware of the awkwardly leaning positions of
these forms, the bunched folds of the tablecloth,
and the candle snuffer pushed to the unstable
foreground edge. Books for Peto were embodi-
ments of learning, here isolated before us to
contemplate, even as their frayed condition
insists on reminding us of time's sad passage.
JW

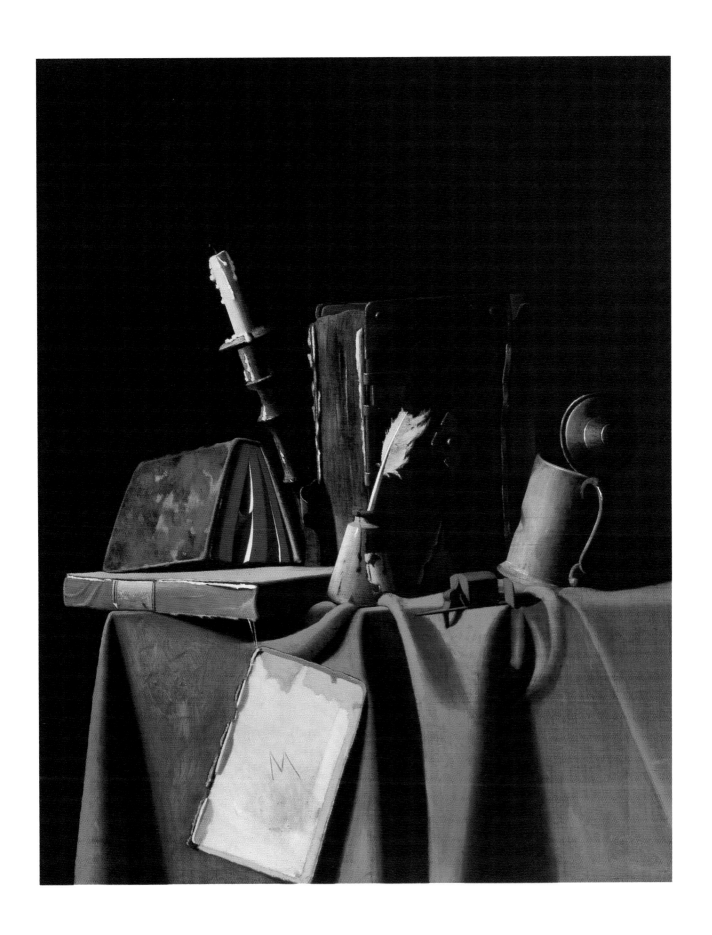

37

John Frederick Peto
1854-1907
Old Time Letter Rack, 1894
Oil on canvas, 30 x 25⅛ inches (76.2 x 63.8 cm)

In his fully mature style Peto evolved two
distinct types of still life painting: tabletop
compositions and arrangements of hanging
objects on illusionistic wall boards or doors.
Whereas the former concentrated on the three-
dimensional textures and masses of forms tightly
set on the receding platforms of a table or shelf,
this second category exploited the even more
demanding illusionism of objects placed against
an upright flat plane at one with the canvas
itself. As with many of Peto's subjects, there
were well-known precedents for this format in
seventeenth-century Dutch and eighteenth-
century English art as well as in examples
occasionally executed by his friend Harnett and
other contemporary colleagues such as John
Haberle. But far more than they, Peto became
intensely preoccupied by the so-called office
board and letter rack designs, both as forms of
personal history and as challenging exercises in
visual playfulness. These works incorporated
not only the commonplace bric-a-brac of his
daily life and household, but also subtler refer-
ences to the more private pressures of his inner
thoughts and artistic concerns. The cropped,
upside-down photograph, for example, at the
center left here is almost certainly a portrait bust
photograph of Lincoln that Peto often used at
this time, thought to have been an image of
untimely loss associated with the recent death
of Peto's father. The general wear and tear of
things more broadly evokes the poignant sense
of change in *fin-de-siècle* America, while the
striking abstraction of design and color signals
Peto's unconscious predictions of modernism.

This particular rack picture began the second of
two series Peto undertook, the first in the late
1880s much lighter in palette and crisper in exe-
cution. After a period devoted to other themes,
he took up the format again in the late nineties
and early 1900s with a greater feeling of gravity
and psychological resonance. This painting is
also notable for its history of having long borne a
false Harnett signature, symptomatic of the con-
fusion in artistic personalities that has haunted
our appreciation of Peto until recent years. *JW*

93

38

Edward Henry Potthast
1857-1927
In the Surf, 1914
Oil on panel, 12 x 16 inches (30.5 x 40.6 cm)

When Potthast moved to New York in 1896 he was nearly forty years old and had already been earning a living as a commercial artist. Working on deadlines for various magazines, including *Scribners* and *The Century*, Potthast developed a system of notation that enabled him to transcribe scenes "on the spot," quickly and adeptly; he applied this approach to his oil paintings as well. He is said to have worked entirely outdoors, preferring to make small oil sketches on wood panel or canvas mounted on board, which he often incorporated into larger studio compositions.[1] Rendered in both crusty, light-charged impasto and free-flowing washes, Potthast's plein-air beach scenes, particularly, won the favorable attention of his contemporaries and the admiration of later collectors and critics. In his own mind, these were "only sketches," [2] but in their simplicity and immediacy, these paintings are often the most personal and expressive statements in his work.

Potthast's dexterity in manipulating pigment is evident in this work of 1914, a colorful depiction of women and children enjoying the sun and surf on a breezy day. As was typical for Potthast, the figures are depicted in broad strokes, with no attempt to individualize their features. They are just a few grace notes in a quietly happy composition.

At the time of this work, Potthast's favorite watering place was Coney Island, located about nine miles off the southern end of Manhattan. In the early years of the twentieth century, it was the most popular seaside resort in the United States. There were cafés, dance halls, beaches, scenic railroads, and large amusement parks. In the era before air-conditioning, it is only natural that thousands of middle-class New Yorkers would flock to Coney Island to escape the heat. Family groups picnicking and bathing provided Potthast with an infinite variety of subject matter and figure compositions that he recorded in oil sketches and studio works. The beach life of New York became his virtual trademark. *NRS*

[1]Potthast Papers, Archives of American Art, Washington D.C., roll N738, frame 445.

[2]ibid., frame 428.

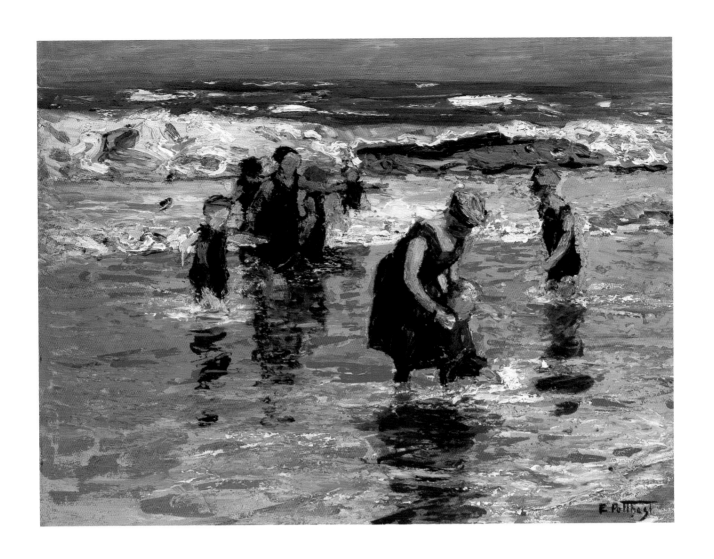

Maurice Prendergast
1858-1924
Cove with Figures, ca. 1920
Oil on canvas, 27 x 33 inches (69.2 x 84.5 cm)

Prendergast painted scenes of people engaged in leisure activities throughout his career. However, his later work is more abstract and concerned more with manipulating space and creating a decorative image than recognizably depicting a precise location. The paintings become complex arrangements of shape, texture, and color. *Cove with Figures* is typical of this period. The composition takes on a two-dimensional quality, as Prendergast foreshortened the picture plane, placing the figures in front of the cove and compressing the space. As a result, the grassy area can be interpreted either as a hill or as a large lawn. The faceless figures function as ornamental elements; the human quality has been all but removed. Prendergast's short, quick brushstrokes and high-key palette create a sense of activity, and the juxtaposed colors provide some illusion of depth. Yet the scene in no way intended to tell a story.

During this later period, Prendergast frequently repeated compositions, often painting over existing works. This work is one of three with similar elements: the large tree, the figures in the foreground, and the distinctive cove. If they were all intended to represent the same scene, it would be the coast south of Boston. However, the level of abstraction in these works makes it impossible to identify a specific location. Yet, Prendergast's interest was not in topography but in pictorial form. *JWT*

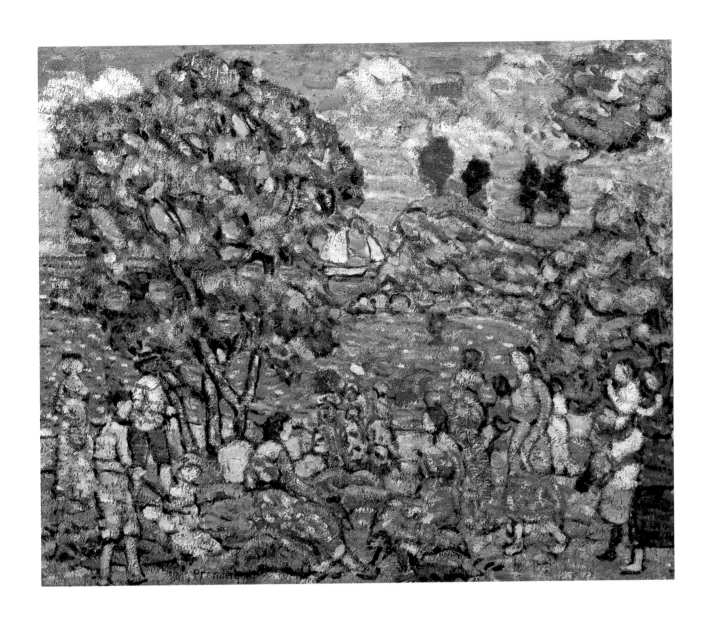

40

Robert Reid
1862-1929
Reverie, 1890
Oil on panel, 11⅞ x 20⅛ inches (30.2 x 51.1 cm)

For most of his career, Reid was generally known as a decorative painter and muralist. He began his successful involvement with decorative design in 1893 when he was commissioned to paint one of the eight domes in the Liberal Arts Building at the World's Columbian Exposition in Chicago. Later commissions included churches, hotels, and court houses in Boston and New York, as well as the Library of Congress in Washington, D.C., and the Fine Arts Building of the Panama-Pacific International Exposition in San Francisco in 1915.

In addition to mural decoration, Reid painted easel pictures throughout his life. Characteristic works depict large-scale figures of attractive women surrounded by the flowers from which they took their names, such as *Fleur-de-Lis* (ca. 1899; The Metropolitan Museum of Art, New York). In his later career, Reid painted what he termed "portrait impressions," which consisted of rapidly sketched portraits on backgrounds of coarse, unprimed canvas.

This vigorously brushed, sun-dappled scene was painted in 1890, a year after Reid's return to America from studying in Paris. In its broken color and immediacy, it suggests the influence of French Impressionism on his work though there is no indication of Impressionist tendencies in the religious and narrative works Reid had painted in France. *Reverie* is one of the few known works executed between Reid's return to New York and the beginning of his commitment to mural work in 1892. The picture has therefore been viewed both as a brief aberration in a career devoted to mural work and as a precursor to his later paintings of women in floral settings.[1] *NRS*

[1]Sally Mills, *American Paintings from the Manoogian Collection.* [exh. cat., National Gallery of Art] (Washington D.C., 1989), 144, no. 52.

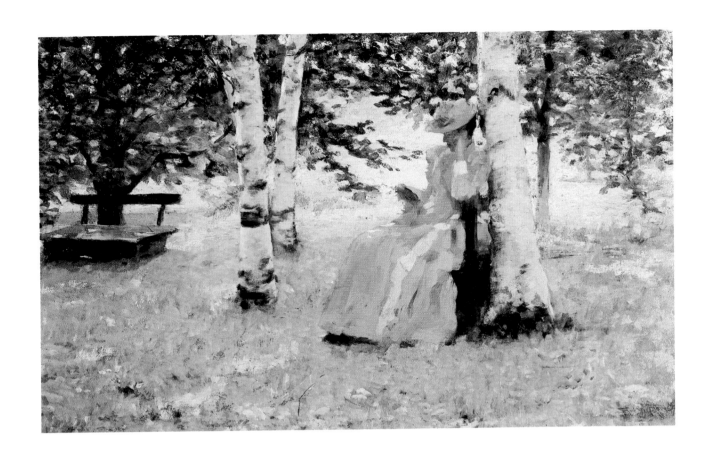

41

Martin Andreas Reissner
1798-1862
The Forest Queen in Winter, 1857
Oil on canvas, 30⅛ x 40⅜ inches (76.5 x 102.6 cm)

The side-wheel steamship, *The Forest Queen*, was built in Cincinnati, Ohio in 1851 and ran between Cincinnati, the "Queen City," and (probably) Lawrenceburg, Indiana. She disappeared from shipping lists in 1859.[1]

The identification of the place depicted in *The Forest Queen in Winter* is as elusive as information about its artist. Family tradition passed down to a former owner of the painting holds that it depicts the artist and his family on the banks of the Ohio River in Covington, Kentucky, looking across at Cincinnati. The railroad along the river's edge corresponds to the route in Cincinnati of the Ohio and Mississippi Railroad, which opened in 1859. But the distant view does not resemble the part of Cincinnati seen from Covington, but is more like the riverside scenery just west of the city. It closely fits an 1857 railway traveler's description of the area: "The Ohio River monopolized the attention of the traveller for nearly twenty miles, the railroad being built right upon its bank, and between it and a range of low hills to the north or west of the stream. This narrow strip of level land is exceedingly rich, covered with beautiful gardens, from which rise many neat and tasteful gardeners' cottages, presenting an agreeable picture of prosperous and contented industry. On the steep sides of the hills which rise backward from this garden strip, cling the vineyards to which we are indebted for the Catawba wines."[2]

The carefully composed, meticulously detailed scene betrays Reissner's background as a panorama painter, drawing on the conventions of panorama painting by presenting a broad spectrum of detail throughout. In a device not uncommon among landscapists, Reissner depicted himself in the foreground painting the scene in his picture. In a witty touch, he illusionistically signed and dated the painting in the snow. *SC*

[1]Frederick Way, Jr., comp., *Way's Packet Dictionary, 1848-1983* (Athens, Ohio, 1983), 169.
[2]William Prescott Smith, *The Book of the Great Railway Celebrations of 1857* (New York, 1858), 218.

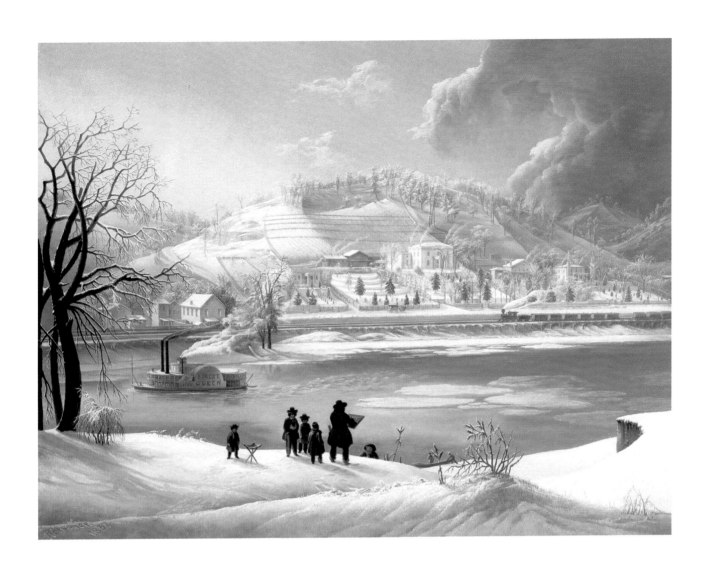

42

John Singer Sargent
1856-1925
Young Girl Wearing a White Muslin Blouse, ca. 1882-85
Oil on canvas, 19½ x 15 inches (49.5 x 38.1 cm)

Throughout his career, Sargent painted small portraits of family members and friends, such as this one, in which he stressed intimacy rather than formality. Here, the natural vulnerability of the teenage girl is suggested in such expressive details as the lips slightly parted, the head gently bent, and the shy averted gaze. In its directness and simplicity, the portrait recalls the paintings of Édouard Manet—whom Sargent admired—especially in its subdued color and the striking beauty of white paint against a dark background. Light streams in from the left, dappling the girl's face, hair, and dress. The melancholy mood of the picture and the wistful face of the innocent girl in white relate to several depictions of young girls at this time, including Sargent's great success at the Paris Salon in 1883, *The Daughters of Edward D. Boit* (Museum of Fine Arts, Boston).

This rapidly brushed portrait was once thought to have been painted at Broadway, England, in the summer of 1885, at a time when Sargent was experimenting with the Impressionist techniques of Claude Monet,[1] but an earlier date of 1882-1885 has been suggested. *NRS*

[1]Warren Adelson, *Sargent at Broadway: The Impressionist Years.* [exh. cat. Coe Kerr Gallery] (New York, 1986) 39.

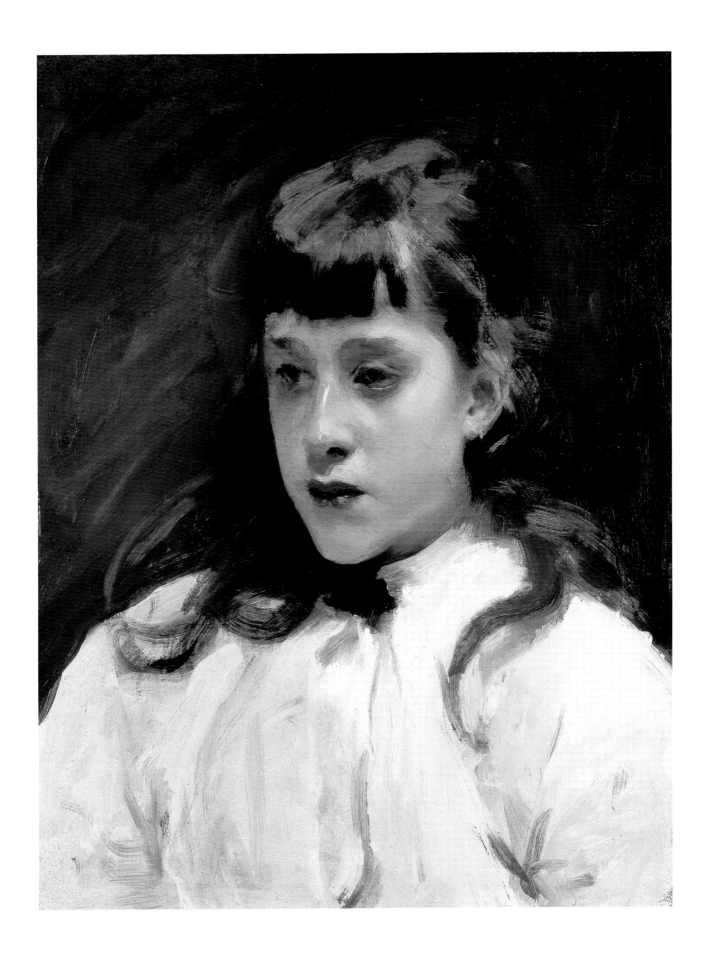

43

Francis Augustus Silva
1835-1886

The Schooner "Progress" Wrecked at Coney Island, July 4th, 1874, 1875
Oil on canvas, 20 x 38¼ inches (51.1 x 96.8 cm)

Silva meticulously recorded the wrecked "Progress" in four watercolors made from 11 July to 15 August 1875. The painting he made from them, with its carefully balanced composition, studied effects of light and atmosphere, and polished handling, represents Silva at the height of his skill as a marine painter. It is undoubtedly the painting titled *A Wreck on Coney Island Beach* that he exhibited at the Brooklyn Art Association in November, 1875.

How Silva learned of the wreck of the "Progress" is unknown. Though he carefully identified and dated the event on his first sketch, it is mentioned neither in the major New York or Brooklyn newspapers nor in official shipping registers.

Silva was drawn to shipwrecks as a subject not only because they were common along the New York coastline, but also because the theme fulfilled his expressive needs. Late in life he wrote that "a picture must be more than a skillfully painted canvas,—it must tell something," and he derided artists who "never paint from memory or feeling...[and in whose works] the subject must convey no sentiment—call up no emotion, awaken no interest."[1] *SC*

[1]Francis A. Silva, "American vs. Foreign-American Art," *The Art Union* 1 (June-July, 1884), 130-131.

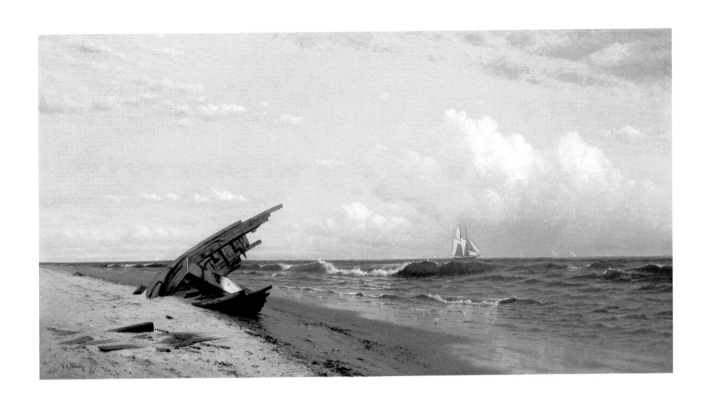

44

Otto Stark
1859-1926
Gathering Wild Poppies, 1885
Oil on canvas, 18 x 14 inches (45.7 x 35.5 cm)

In 1885, Otto Stark arrived in Paris to enroll in the Acadèmie Julian, where he took lessons from the painters Gustave Boulanger and Jules-Joseph Lefebvre. *Gathering Wild Poppies* was painted during Stark's first year in Paris. His academic training is apparent in the careful management of light and shade and the delineation of the young girl.

In many respects, *Gathering Wild Poppies* relates to the paintings of the French artist Jules Bastien-Lepage, whose work was greatly admired by American artists in the 1880s. Like Bastien-Lepage, Stark was basically conservative in his academic treatment of the figure, while at the same time the fluently brushed plein air landscape surrounding her is almost Impressionistic in its effects and gestural strokes of color.

Stark did not fully embrace Impressionism until the decade of the 1890s, but he was aware of its tenets and techniques earlier. In 1895 he published "The Evolution of Impressionism," one of the first defenses of it in America.[1] That evolution went through four stages, from darker colors to the final stage of "complete color value." *Gathering Wild Poppies* belongs to his second stage, which he described as "beautiful in repose, harmonious in tone, [and] generally without shrill notes of any kind." *AT*

[1]"The Evolution of Impressionism," *Modern Art* 3 (Spring, 1895), 53-56.

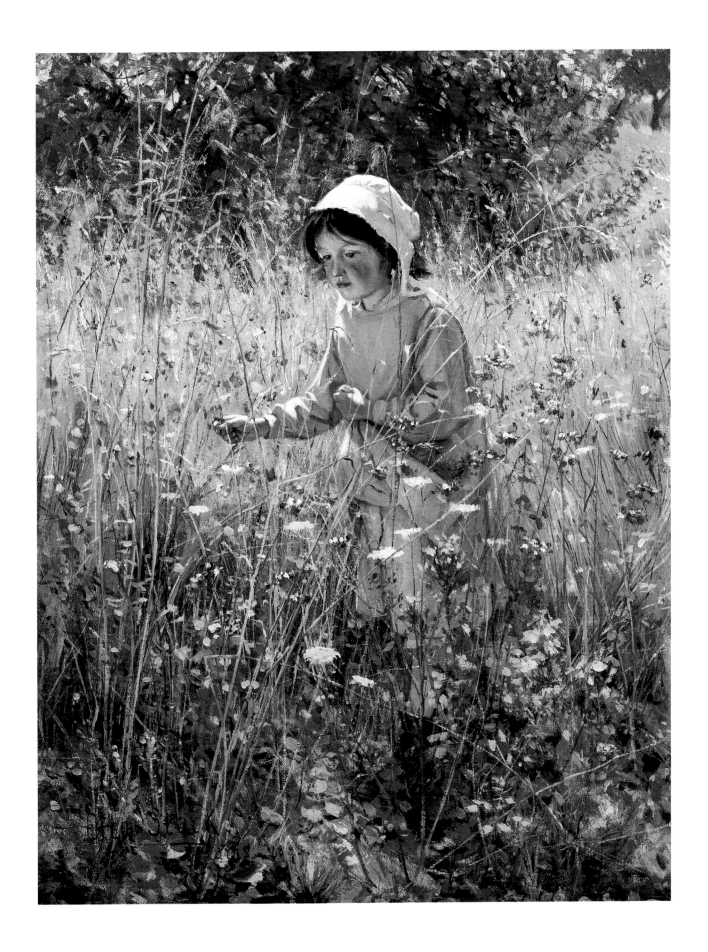

45

Julius L. Stewart
1855-1919
Summer, 1880
Oil on canvas, 33½ x 58¾ inches (85.1 x 149.2 cm)

In *Summer,* Stewart is primarily concerned with
capturing the evanescent light and color of the
landscape of the Ile de France on a summer
day, and demonstrates an early, if only passing,
recognition of plein-air Impressionism. The
figures are incidental to the landscape, but they
are not mere staffage. The man in the back-
ground is certainly the artist's father, the
connoisseur and collector William Hood Stewart,
presumably accompanied by the artist's mother,
and one of the foreground figures is probably
his sister Ellen.

Summer was well regarded by its painter, for he
sent it for exhibition to the Paris Salon of 1882.
DDT

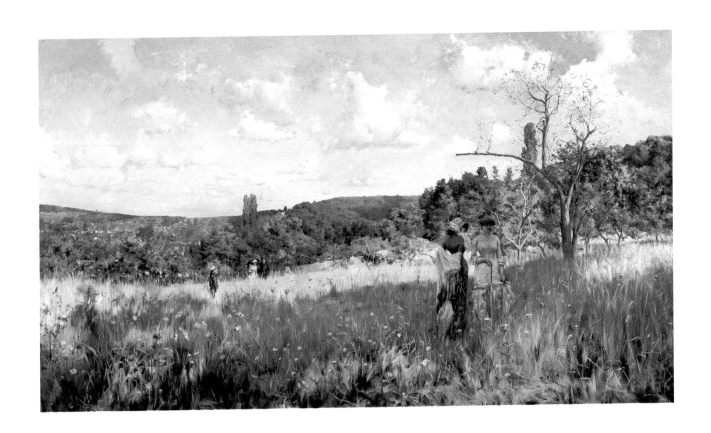

46

Arthur Fitzwilliam Tait
1819-1905
The Life of A Hunter: A Tight Fix, 1858
Oil on canvas, 40 x 60 inches (101.6 x 152.4 cm)

An avid sportsman as well as an artist, Tait first visited the Adirondack Mountains of upstate New York in 1852 and returned there regularly until 1881. Tait painted deer, grouse, and other woodland creatures he encountered during his travels. However, he was particularly fascinated with the black bear, an animal he had not seen before in the wild. His interest in this animal was so great that he actually raised a half-tame bear cub himself,[1] which helps to explain the sense of realism he was able to bring to his various depictions of this animal.

Tait's first painting of a bear, a close-up view of one accosted by bees while attempting to steal honey (*The Robber,* private collection, New York), was exhibited at the National Academy of Design in 1852. Six years later, he presented *The Life of a Hunter: A Tight Fix,* a winter subject depicting the tense moment just after a hunter has shot his prey. The success of this painting was immediate. Critics found the drawing admirable, the color true to nature, and the picture one of the most pleasing they had seen in some time.[2] In 1861 Tait painted a second, slightly different version of the subject for Currier & Ives. In this second version, the bear is no longer seated, but rears up on its hind legs, and the hunter is on his knees wielding a knife. This canvas is now lost, and only a few prints of the subject survive because the lithographic stone was accidentally broken. *NRS*

[1]Warder H. Cadbury, *Call of the Wild: A Sportsman's Life.* Hirschl and Adler Galleries, Inc., New York, 1994, unpaginated.

[2]Warder H. Cadbury, *American Paintings from the Manoogian Collection.* [exh. cat., National Gallery of Art] (Washington D.C., 1989), 78, no. 29.

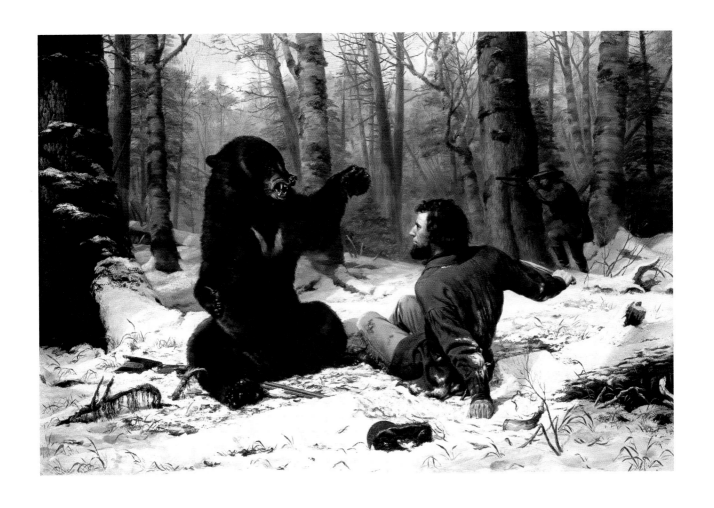

John Henry Twachtman
1853-1902
Last Touch of Sun, ca. 1893
Oil on canvas, 24¾ x 30 inches (108 x 136.8 cm)

Last Touch of the Sun depicts Twachtman's home in Greenwich, Connecticut. Unlike many of his contemporaries who maintained permanent residences in New York and only summered in the small towns along the East Coast, Twachtman lived all year in this farm house, which he purchased in 1889. The house became one of his favorite subjects. He examined the structure from various vantage points, seasons, and times of day and in successive years, as it was transformed into a much larger residence. Twachtman consistently drew on it and other local scenes for subjects of his work.

This canvas shows the house after a heavy snowfall, with the sun of a late winter day casting long shadows. While sunlight is clearly indicated, there is no suggestion of warmth. As is typical of much of Twachtman's oeuvre, one or two colors dominate the canvas. Here the cool blue and white tones are occasionally interrupted by a few elements of purple and red.

Last Touch of Sun was displayed at the American Art Galleries in an exhibition with Claude Monet, Albert Besnard, and Julian Alden Weir. It received very positive reviews; a writer for the journal *Art Amateur* compared the painting favorably to one by Monet, even declaring it more picturesque. *JWT*

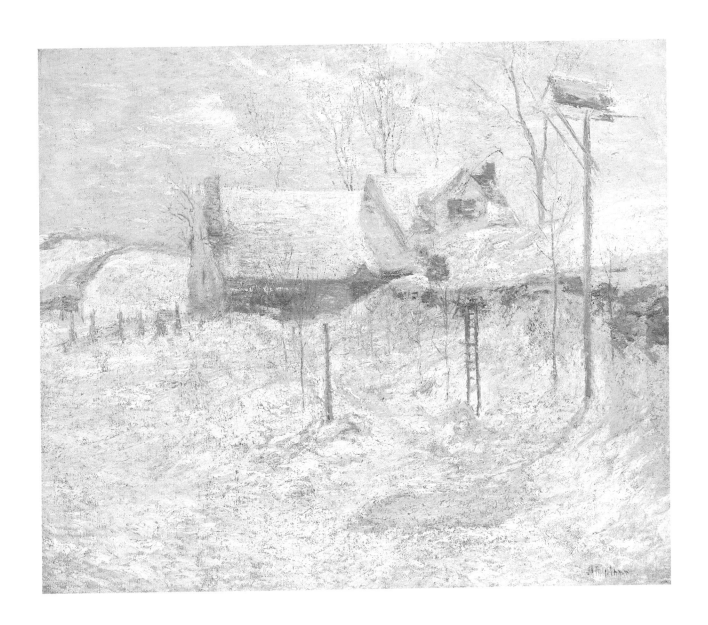

Irving Ramsey Wiles
1861-1948
Afternoon Tea, n.d.
Oil on canvas, 26 x 36 inches (66x91.4 cm)

In almost every way—where he studied and with whom, the artists of the past he admired and the contemporaries he resembled, what he painted and how he painted it, and in his artistic attitude or posture—Irving Wiles was located squarely in the middle of, and thoroughly exemplified, the artistic ethos of his time. In Paris he studied with the popular portraitist Carolus-Duran, the teacher (among others) of John Singer Sargent. He was strongly influenced by the seventeenth-century painters Frans Hals and Diego Velázquez, who were the greatest artistic idols of the age. His subjects—studios, figures in landscapes, and fashionable portraits—were ones he shared with many of his contemporaries, and like many of them he flirted with the colorism and style of French Impressionism. And like many of his contemporaries, too, such as his friend William Merritt Chase, his principle article of belief was that artistic virtue lay more in manner than in meaning or morals: "He would himself rather that his pictures attract the eye by a subtle suggestion of beauty than that they attract attention because of a deed being enacted or the merits of a good or bad deed shown," the writer Theodore Dreiser said. "He presents no intricate symbolism in his work, no revelation of a nature complicated beyond the power to express its thoughts," a critic wrote.[1]

Afternoon Tea is an early work, painted before Wiles largely settled into formal portraiture. From 1884, when he returned to America from his studies in Paris, through the summer of 1894, Irving Wiles and his father, Lemuel, ran the Silver Lake Art School in western New York State, near Geneseo. There he painted *Afternoon Tea*, depicting his wife, who often posed for him, and an unidentified woman (probably a student at the school). Another painting, *By the Lake*, dated 1889, depicts the same sitters at the same location but from the far side of the hammock.[2] Paintings of figures in a summer landscape would be a staple of the work that Wiles' friend Chase would paint at Shinnecock, Long Island, during the 1890s. *NC*

[1]Dreiser, "Art Work of Irving R. Wiles,' *Metropolitan Magazine* 7 (April 1898), 359; William B. McCormick, "The Portraits of Irving R. Wiles," *International Studio* 77 (June 1923), 261.

[2]See Gary A. Reynolds, *Irving R. Wiles,* [ex. cat. National Academy of Design] (New York, 1988), pl. 8.

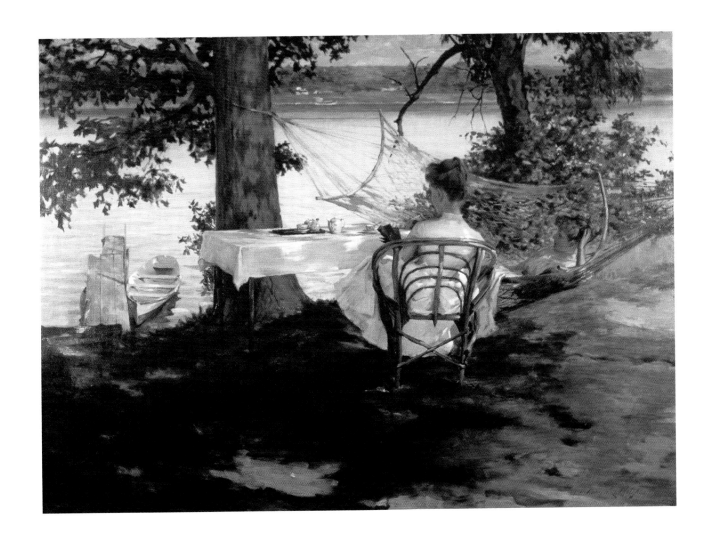

49

George Wright
n.d.

I Won't!, 1887
Oil on canvas, 24½ x 30¼ inches (62.2 x 76.8 cm)

Virtually nothing is known about George Wright
himself, except that he was a Philadelphia artist
who exhibited at the Pennsylvania Academy of
the Fine Arts, the National Academy of Design
(New York), the Louisville Industrial Exposition,
and Powers Gallery in Rochester, New York, in
the period 1875-1894. *I Won't!* was exhibited at
the National Academy in 1888 (for sale at $250).
Judging from the titles of other works Wright
exhibited—*Dis-Concerted by Mosquitos* (1879),
Happy Hours (1886), *The Day After the Party*
(1887), *Aboard the "City of Paris," off the Banks*
(1890), *"Are They Bride and Groom?"* (1892)—
I Wont'! is characteristic of the amusingly
narrative genre paintings that comprise the bulk
of his known work. It is characteristic, too, of a
subject, the artist's studio, that was a favorite
one in the late nineteenth century. *NC*

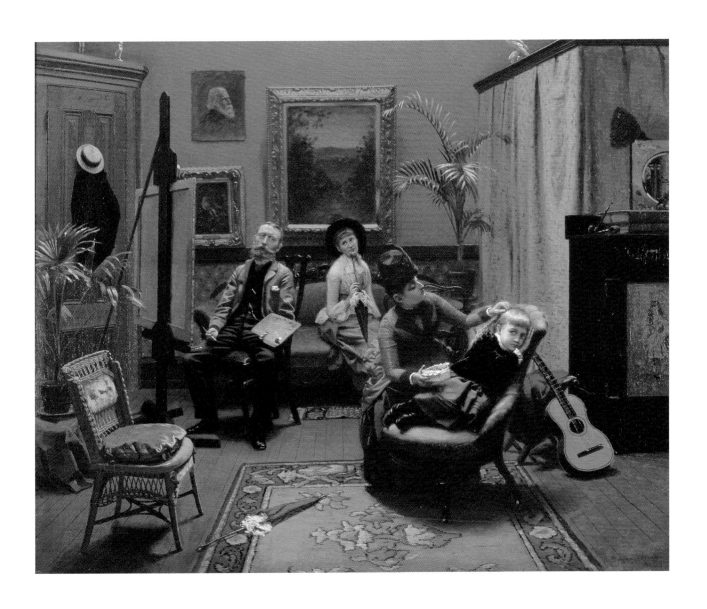

ARTIST'S BIOGRAPHY

Otto Henry Bacher
1856-1909

Born in Cleveland, Ohio, Otto Bacher set out for Europe in 1878. He studied at the Munich Royal Academy before joining Frank Duveneck's painting classes with several other American artists. The "Dunveneck Boys" traveled to Italy and by 1880 were painting and etching with James McNeill Whistler in Venice. Bacher stayed in Italy through 1882, before returning to Cleveland. He taught classes at his studio and at the Cleveland Art Club. In 1883 with Joseph De Camp, a former student of Duveneck, Bacher established a summer art colony in Richfield. In 1885, Bacher attended the Acadèmie Julian in Paris. Although he settled in New York City in the spring of 1887, Bacher kept his ties to Cleveland by participating in the city's exhibitions and periodically visiting the Cleveland Art Club. *VK-H*

Frank Weston Benson
1862-1951

Born and raised in Salem, Massachusetts, Benson began his art training in 1880 at the School of the Museum of Fine Arts in Boston. From 1883 to 1885, he studied at the Acadèmie Julian in Paris under Jules-Joseph Lefebvre and Gustave Boulanger. During the summer months he painted at Concarneau in Brittany. On his return to the United States in 1885, Benson joined the staff of the Portland School of Art in Maine and began exhibiting portraits and landscapes in Boston and elsewhere. In 1889 he secured a teaching position at the School of the Museum of Fine Arts, Boston, where he remained for nearly thirty years. Benson completed a mural cycle for the Library of Congress in Washington, D.C., in 1896. In 1898 he became a founding member of the Ten American Painters and turned his attention to outdoor subjects. In the mid-teens he turned to sporting scenes, especially salmon fishing and duck hunting, painting them in oil and watercolor. After 1912 Benson also worked as a printmaker. *NRS*

Albert Bierstadt
1830-1902

Born near Solingen, Prussia, Bierstadt emigrated to America with his parents in 1831, and the family settled in eastern Massachusetts. By 1851 he had begun painting in oils. Two years later, he returned to Düsseldorf to study and spent the next four years traveling through Germany and Italy. Following his return to the United States, Bierstadt went to the American West on survey expeditions, visiting the Rocky Mountains, California, and Oregon. The paintings he executed based on sketches of those regions brought him both critical and financial success, and he continued to paint monumental landscapes throughout his life. *JWT*

Robert Frederick Blum
1857-1903

Born in Cincinnati, Ohio, Blum studied art locally at the Mechanics Institute and the McMicken School of Design. In 1876, he furthered his art education at the Pennsylvania Academy of the Fine Arts in Philadelphia. While there he visited the Centennial Exposition, where he admired the contemporary paintings of the artists Mariano Fortuny and Giovanni Boldini and developed a lifelong interest in Japanese art and culture. Blum obtained a position as an illustrator at the publisher Scribner & Sons in New York in 1877. In 1880, he was sent on assignment to Europe, where he visited Venice, among other places, and met the American artists Frank Duveneck and James McNeill Whistler. In the 1890s Blum spent two years working in Japan. After his return to the United States, he was commissioned by his patron, Alfred Corning Clark, to complete a series of murals for the Mendelssohn Glee Club in New York City, which occupied most of his time until 1898. Afterward, he began a plan for another mural project and was working on it at the time of his death. *NRS*

Alfred Thompson Bricher
1837-1908

Born in New Hampshire, Bricher was largely a self-taught artist. In 1851 he moved to Boston, where he worked as a clerk and began painting. When he decided to become a professional artist in 1858, Bricher established a studio in Newburyport, Massachusetts. The following year he returned to Boston, where he worked as an artist for ten years. Bricher began to turn his attention from landscapes to marine painting after moving to New York in 1868. He opened a studio there, and the popularity of his works, which were widely available through lithographs, brought him success. Bricher often traveled in the eastern United States, spending many summers on the New England coast and visiting the Catskill and White Mountains—all of which served as inspiration for his work. *JWT*

John George Brown
1831-1913

Brown was raised in Newcastle-on-Tyne, England. At the age of fourteen he began a seven-year apprenticeship in the glass cutting trade. During this period, he studied drawing at the Government School of Design under William Scott Bell. In 1852 he moved to Edinburgh and studied briefly at the Trustees Academy. Brown emigrated to America in 1853 and settled in Brooklyn. In 1857 he enrolled in classes at the National Academy of Design, where he began exhibiting the following year. Brown painted landscapes, portraits, and rural genre scenes, but his most popular subject was the urban street urchin, usually bootblacks and newsboys who posed in his studio. He also painted fishermen at Grand Manan Island, New Brunswick, Canada. *NRS*

William Merritt Chase
1849-1916

Chase developed an interest in art at an early age. He studied art in his native Indiana, and in 1869 entered the National Academy of Design. Chase sailed to Europe in 1872 and studied at the Royal Academy in Munich. In 1878 he returned to New York and established a studio. He was elected a member of the National Academy of Design in 1890. A prominent instructor, Chase taught at the Art Students League during three stints from 1878 to 1909 as well as at the Brooklyn Art Association (1887 and 1891-95) and the Pennsylvania Academy of the Fine Arts (1896-1909). He was instrumental in the formation of both the Shinnecock Summer School of Art and the Chase School of Art, known today as the Parsons School of Design. Chase was a leading painter of his generation and had continued success until his death. *JWT*

Frederic Edwin Church
1826-1900

Born to a wealthy family in Hartford, Connecticut, Church opposed his parents' desire that he go into business and instead chose to pursue a career as an artist. He received his early training from local painters. In 1844, now with his father's support, he financed two years of study with Thomas Cole. At age twenty-three, Church was considered one of the country's leading young painters. He made two trips to South America, in 1853 and 1857, which inspired Church to produce such important works as *The Heart of the Andes* (1859; The Metropolitan Museum of Art, New York) and *Cotopaxi* (1863; The Detroit Institute of Arts). Church remained active through the 1880s, although his popularity began to decline towards the end of his career. His work was rediscovered in the 1960s. *JWT*

James Goodwyn Clonney
1812-1867

Clonney was born in Liverpool, England, in 1812, and little is known of his early life. By 1830 he was listed as working for a New York lithographer. He studied at the National Academy of Design in the early 1830s, first exhibiting there in 1834. Clonney's early work consisted primarily of landscapes and miniatures, but in the early 1840s he began painting genre scenes, typically depicting middle-class Americans sharing such experiences as hunting or fishing. Clonney enjoyed a modicum of popularity throughout the 1840s and 1850s, living in upstate New York. He stopped exhibiting in New York City in 1852 when he moved to Cooperstown. As tastes and styles changed, interest in his genre paintings declined, and very few works are known from the last decade of his life. *JWT*

Charles Courtney Curran
1861-1942

Born in Kentucky but raised in Ohio, Curran studied at the Cincinnati School of Design as well as the National Academy of Design and the Art Students League in New York. He began exhibiting at the National Academy of Design in the early 1880s. In 1889 he left for two years study at the Acadèmie Julian in Paris, where he worked under Jules-Joseph Lefebvre and Benjamin Constant. He exhibited at the Paris Salon from 1889 to 1891, winning an honorable mention in 1890 for *Lotus Lilies of Lake Erie* (1888; Terra Museum of American Art, Chicago). Following his return to the United States in 1891, Curran exhibited his work in New York and taught classes at Brooklyn's Pratt Institute (1895-96) and at the Art Students League (1901-4). After 1903 he resided most of the time at the Cragsmoor artists' colony in upstate New York. There, young women, often posed high on a hill or mountaintop and silhouetted against a brilliant blue sky, became his principal theme. *NRS*

Thomas Wilmer Dewing
1851-1938

A native of Boston, Dewing studied briefly at the School of the Museum of Fine Arts, then left for Europe in 1876. In Paris he studied with Gustave Boulanger and Jules Lefebvre at the Acadèmie Julian. He was also inspired by the art of a number of eighteenth-and nineteenth-century French painters as well as seventeenth-century Dutch artists such as Jan Vermeer. Upon his return to America in 1879, Dewing opened a studio in Boston. Two years later he moved to New York, where he taught at the Art Students League. In 1897 he joined the Ten American Painters, a group composed largely of American Impressionists, and exhibited with them on a regular basis during their twenty-year association. A figure and portrait specialist, he is best known for his paintings of women shown in undefined, atmospheric spaces or in sparsely furnished interiors. *NRS*

Robert Spear Dunning
1829-1905

Dunning was born in Maine, where he lived until his family moved to Fall River, Massachusetts. He displayed an intense interest in art at an early age and in his early twenties, studied with James Roberts of Thomaston, Maine. In 1849, he moved to New York, where he remained for four years, studying at the National Academy of Design. Dunning's early work consisted of portraits and seascapes, but by the mid-1860s his primary subject was arrangements of fruit. He exhibited at the National Academy in the 1880s. Dunning's painting style was considered old-fashioned long before his death at age seventy-six. Yet in Fall River, his work remained popular through-out his life; he had a loyal local artistic following that became known as the Fall River School. *JWT*

Asher Brown Durand
1796-1886

Born in New Jersey, Durand spent his early career developing his engraving skills. In 1817 he became a partner with his mentor, Peter Maverick, and moved to New York to manage a branch of their firm. Inspired by the work of Thomas Cole, he turned his attention to painting in 1837. Three years later, Durand traveled with John F. Kensett to Europe, where he was influenced by the work of Claude Lorraine. By the mid-1840s, Durand adopted the Hudson River School philosophy of painting landscapes directly from nature. He became a great proponent of this manner of painting and in 1855 published "Letters on Landscape Painting," in which he formally stated his beliefs. He encouraged artists to take sketching trips to the mountains of the eastern United States in the summer and early fall and then to paint from these notes on nature during the winter. His work sold well, and Durand was active in the art world until his retirement in 1869. *JWT*

George Henry Durrie
1820-1863

Very little is known of Durrie's early life and training. Born in Connecticut, he began his artistic career as an itinerant portrait painter and later supported his family by painting signs and window shades and restoring paintings. Toward the end of the 1840s he eventually concentrated on landscapes. His early landscapes show the influence of Thomas Cole and Frederic Church. However, as his work matured, he turned his attention to winter scenes, prominently incorporating human figures. It was with these canvases that Durrie realized some success, as the company Currier & Ives made his work widely available in the form of prints. He exhibited sporadically at the National Academy of Design from the mid-1840s until his death in 1863. *JWT*

Thomas Eakins
1844-1916

Born and raised in Philadelphia, Eakins began taking courses at the Pennsylvania Academy of the Fine Arts in 1862. He also attended anatomy lectures there and at the nearby Jefferson Medical College. In 1866 he went to Paris, where he attended the Ecole des Beaux-Arts and worked under Jean-Léon Gérôme. He also studied briefly with Léon Bonnat and the sculptor Augustin Dumont. Before returning to America in 1870, Eakins spent six months in Spain studying works by Velázquez, Ribera, and Rembrandt, all of whom would influence his later work. Upon his return, Eakins taught life classes at the Philadelphia Sketch Club (1874-76) and in 1878 began teaching painting and drawing at the Pennsylvania Academy of the Fine Arts. In 1886 he was forced to resign his position at the Academy because of a controversy over his insistence on working from the nude model. When he left, a number of his students departed with him, and together they established the Philadelphia Art Students League, where Eakins taught for the next several years. During the 1890s, Eakins was also active as a sculptor. Portraiture dominated his last productive years. *NRS*

John F. Francis
1808-1886

Little is known of Francis's early life or training. Born in Philadelphia in 1808, he began his career as an itinerant portrait painter, working in Pennsylvania, Tennessee, and Ohio. In the 1840s his work was dominated by portraits reminiscent of those of Thomas Sully (1783-1872), and he began exhibiting in Philadelphia at the Artists' Fund Society and the Pennsylvania Academy of the Fine Arts. His last known portrait was painted in 1852. Two years earlier he had begun to turn his attention to still life, which would be his sole manner of expression for the remainder of his career. These elaborate compositions, typically consisting of food and its containers, were very popular and provided Francis with a comfortable income. He apparently retired from painting after 1879 and spent the remainder of his life in rural Pennsylvania. *JWT*

Frederick Carl Frieseke
1874-1939

Michigan-born Frederick Frieseke studied briefly at the School of the Art Institute of Chicago and the Art Students League in New York before going to the Acadèmie Julian in Paris in 1898. He also had some instruction from James McNeill Whistler, whose tonalist concerns influenced Frieseke's early work. In 1900 Frieseke debuted at the American Art Association of Paris. He was a member of all of the important art societies in France and the United States and exhibited in Italy at the Venice Biennale and on occasion in London at the International Society shows. In 1906 he rented Theodore Robinson's former residence at Giverny and for the next thirteen years was the summer neighbor of Claude Monet. Although Frieseke's contact with the French master appears to have been minimal, his early style now gave way to what has been termed his "high impressionist" period, in which the varied effects of sunlight became his principal concern. While Monet and Pierre-Auguste Renoir were the major influences on his work, Frieseke's predilection for strongly patterned surfaces suggests the additional influence of Edouard Vuillard and Pierre Bonnard. *NRS*

Daniel Garber
1880-1958

Born in Indiana, Garber began his artistic training in 1897 at the Art Academy of Cincinnati. Two years later, he attended the Pennsylvania Academy of the Fine Arts, studying with William Merritt Chase, among others. During this period he opened a studio, where he specialized in portraiture and illustration. Garber exhibited frequently, winning several awards. His success enabled him to study in London, Florence, and Paris, where he exhibited a few paintings at the Salon before returning to the United States in 1907. That same year, he began teaching at the Philadelphia School of Design for Women, where he remained for nearly three years. From 1919 until 1950, he taught at the Pennsylvania Academy of Fine Arts. Garber's achievements continued to be recognized throughout his career, and he left behind an extensive body of work. *JWT*

Sanford Robinson Gifford
1823-1880

Raised in Hudson, New York, Gifford went to New York City in 1845 to study drawing with John Rubens Smith; he supplemented his art training at the National Academy of Design and sketched from nature on walking tours in the Catskill and Berkshire Mountains in New York and Massachusetts. In 1855 he made his first trip to Europe, where he sketched the scenery of England, Scotland, and Wales, visited the major art galleries and private collections, and called on the art theorist John Ruskin. For the next year he toured France, Belgium, Holland, Germany, and Switzerland before arriving in Italy, where he painted the landscape and ruins of the countryside. During his European travels, Gifford turned away from the darker, balanced compositions of the Hudson River School to a new stylistic emphasis on light and atmospheric effects. Gifford went abroad again in 1868 and spent two years sketching in the Middle East. Several of his major canvases resulted from this trip. *NRS*

William Glackens
1870-1938

Born in Philadelphia, Glackens received his early training at the Pennsylvania Academy of the Fine Arts. He worked as an illustrator at numerous local newspapers and gradually became associated with artists who, along with Glackens, would later form the core of The Eight. In 1895 he traveled to Europe to study the old masters, but he was also drawn to the work of Édouard Manet. He returned to the United States a year later and settled in New York. Following a second, longer visit to Europe, he exhibited with The Eight in New York, but afterward he turned from their realism to the style of the French Impressionists; by 1913, he was completely under the influence of Pierre-Auguste Renoir. For the remainder of his life, he continued to travel to France, acquire works for his long-time friend Albert Barnes of Philadelphia, and paint. *JWT*

William Michael Harnett
1848-1892

Harnett emigrated with his family from Ireland to Philadelphia before he was two years old. In 1865 he was apprenticed to an engraver, and two years later he began to take classes at the Pennsylvania Academy of the Fine Arts. He moved to New York in 1869 where he worked as an engraver while taking classes at the National Academy of Design and the Cooper Union. In 1875 he established a studio and began to paint still lifes. He returned to Philadelphia in 1876 where he lived until he went to Frankfurt in 1880. In 1885 Harnett moved to Paris for a year and exhibited at the Salon, *After the Hunt* (California Palace of the Legion of Honor, San Francisco), possibly his most renowned painting. Upon his return to New York, he entered the most successful stage of his career. Unfortunately, it was cut short when he died after a brief illness in 1892. *JWT*

William Stanley Haseltine
1835-1900

William Stanley Haseltine was born into an artistic Philadelphia family. He studied under Paul Weber and, after graduating from Harvard in 1854, he followed Weber to Germany. After making sketching trips to the Rhine and Italy, Haseltine returned to America in 1858, where he was elected to the National Academy of Design. Before returning to Europe in 1866 to study with the Barbizon School of painters, Haseltine painted several views of the New England coast. He died in Rome in 1900. *VK-H*

Childe Hassam
1859-1935

Born in Dorchester, Massachusetts (now a part of Boston), Hassam attended classes at the Boston Art Club and the Lowell Institute and studied painting with the Munich-trained artist Ignaz Gaugengil. In the early 1880s he established a studio in Boston and also exhibited his work in Philadelphia and New York. In 1886 he went to Paris to study at the Académie Julian, where he remained for three years. Despite his pursuit of academic training, it was during these years that Hassam first truly embraced the principles of Impressionism. After 1889 he settled in New York City and became active in the Pastel Society, the New York Watercolor Club, and the Society of American Artists. In 1897, along with nine other artists, he resigned in protest from the society to found the Ten American Painters, with whom he exhibited throughout their association (1898-1918). Beginning in 1890 and for the next twenty years, Hassam spent the summer months painting on Appledore Island, off the coast of Maine and New Hampshire. Other favorite seasonal locations were Gloucester and Provincetown, Massachusetts; Newport, Rhode Island; and the Connecticut towns of Cos Cob and Old Lyme. *NRS*

Martin Johnson Heade
1819-1904

Born in Bucks County, Pennsylvania, Martin Johnson Heade was encouraged by his father to become an artist. Heade first studied with the American artist Edward Hickshe. In 1838, he went to Rome for two years of study. His early work was dominated by portraiture. However, from the mid-1840s he turned his attention to landscape and still-life painting. Heade was an avid traveler, visiting Europe, South America, Central America, and British Columbia. In the United States he traveled to Narragansett Bay and the salt marshes and coasts of Massachusetts, Rhode Island, Connecticut, and New Jersey. Heade's interest in the tropics was reflected in the two dominant subjects of his paintings: exotic landscapes and hummingbirds. In 1883 he moved to Saint Augustine, Florida, where he became the leading figure of a small artists' colony. *JWT*

George Inness
1825-1894

Inness was born in Newburgh, New York, received his early training from an itinerant painter in Newark, New Jersey, and was later apprenticed to the engravers Sherman and Smith of New York. In 1844 he first exhibited at the National Academy of Design, where his landscapes differed from those of his contemporaries in that he was not concerned with accurately recording nature. After he had traveled in Europe (1850-54), Inness's work began to reflect the poetic ideas of the French Barbizon painters. In the 1860s he fell under the influence of the religious thinker Emanuel Swedenborg. Following another visit to Europe, he settled in Montclair, New Jersey, where he spent the remainder of his life. The countryside of this area was the dominant subject of his later canvases. *JWT*

Ernest Lawson
1873-1939

Ernest Lawson was born in Halifax, Canada, and joined his family in Kansas City at the age of fifteen. He began studying painting at the Kansas City Art Institute, but only a year later, in 1899, the family moved to Mexico City, where Lawson worked as a draftsman and took classes at the Santa Carlos Art School. At the age of eighteen he moved to New York to study at the Art Students League, and in 1893 he went to Paris to study at the Académie Julian, returning in 1898. In 1904 Lawson met William Glackens and through him the other members of The Eight. He spent the late 1920s painting in Kansas City and Colorado Springs and returned to New York in 1929. Because of the Great Depression, the 1930s were a difficult period for Lawson both artistically and financially. His life ended mysteriously in 1939 when his body was found floating off Miami Beach, Florida. It was assumed that he had died of a heart attack. *JWT*

Willard Leroy Metcalf
1858-1925

Metcalf studied in Boston, then worked as an illustrator for various magazines. He advanced his training in 1883 at the Académie Julian in Paris, spending the summer months working in Brittany, Grez-sur-Loing, and Giverny, where he presumably became acquainted with the work of Claude Monet. During this period he worked in a Barbizon mode, experimenting at the same time with the high-key palette of Impressionism. In 1889, Metcalf returned briefly to Boston, then moved to New York, where he taught at the Art Students League and the Cooper Union. After 1897 he exhibited regularly with nine other prominent artists; this group came to be known as the Ten American Painters. Yet Metcalf's work chiefly portraits in the 1890s received only limited critical attention until after 1903, when he turned anew to landscape painting. The success of what Metcalf termed his "first personal exhibition," held at Fischel, Adler, and Schwartz Gallery, New York, the following spring, was immediate. From that time on, the artist devoted himself to recording the changing moods and seasons of the New England countryside. *NRS*

Louis Remy Mignot
1831-1870

Mignot was born in South Carolina in 1831. At the age of seventeen, he traveled to Europe to study art at The Hague in Holland under the instruction of Andreas Schelfhout. Returning to the United States in 1855 he opened a studio in New York. Mignot was building a strong reputation as an artist when Frederic Church invited him to travel to Ecuador. The paintings realized from his sketches on the journey gained Mignot considerable success and led to his election to full membership in the National Academy of Design in 1859. Sympathizing with the South during the Civil War and thus uncomfortable living in New York, Mignot moved to England in 1862. He continued to paint and exhibit at the Royal Academy until he died prematurely of smallpox in 1870. *JWT*

Francis Davis Millet
1846-1912

Millet was born in Massachusetts and attended Harvard University, earning an M.A. in 1869. It was here that he first began to experiment with painting. After graduation, he went to work as a reporter for a Boston newspaper, established a studio, and began to study lithography. He went to Antwerp in 1871, attending the Royal Academy there for two years. Millet returned to Boston in 1875 as a portrait painter. The following year he exhibited first at the National Academy of Design and then at the Centennial Exposition in Philadelphia. For the remainder of his life, Millet's work included genre and period scenes, and he was involved in most of the major expositions on both sides of the Atlantic. Maintaining residences in both the United States and England, he was a frequent traveler on the great ocean liners that crossed the Atlantic. In 1912 he set sail from Liverpool to New York on the *Titanic*. He never reached his destination. *JWT*

Jerome Myers
1867-1940

Born in Petersburg, Virginia, Jerome Myers began his career as a sign painter in Philadelphia and then Baltimore. After 1886, he settled in New York City where he studied in the evenings at the Cooper Union and the Arts Students League. During the day, he earned a living by painting theater sets and by working in the art department of the *Herald Tribune*. His paintings depict lower-class life in New York, about 20 years before the Ashcan School. Myers became associated with the emerging realist artists, but he was never considered one of The Eight because of his light colors and the light-hearted quality of his works. In 1913, he exhibited at the New York City Armory Show. Myers published an autobiography entitled, *Artist in Manhattan*, a few years before his death in 1940. *VK-H*

Johannes Adam Oertel
1823-1909

Born in Bavaria, Oertel was a devoutly religious man. Encouraged by his pastor, he pursued an artistic career, studying painting and engraving in Nuremberg and Munich. In 1848 he emigrated to the United States and supported himself by teaching, portrait painting, and engraving bank notes. He began exhibiting his work at the American Art Union and the National Academy of Design in 1850, and in 1854 he received a commission to decorate parts of the Capitol in Washington D.C. In 1871, Oertel became a priest in the Episcopal Church. For about the next twenty-five years he moved frequently, serving as a parish priest and producing various religious objects. After he retired in 1894 Oertel completed a cycle of four paintings on the redemption of man. *JWT*

William McGregor Paxton
1869-1941

Paxton grew up in the Boston area and studied with Dennis Bunker at the Cowles School of Art from 1887 to 1889. From 1889 to 1893 he studied in Paris at the Ecole des Beaux-Arts with Jean-Léon Gérôme, and at the Académie Julian. Paxton returned to Boston in 1893 and soon began showing his paintings to increasing acclaim in both Boston and New York. He associated with the group of artists somewhat older than he, known as the Boston School, which also included Frank Weston Benson, Joseph DeCamp, and Edmund Tarbell. In 1906, he joined them on the faculty of the School of the Museum of Fine Arts. During this period he painted portraits and developed the scenes of attractive young women in elegant interiors for which he would become famous. *NRS*

Enoch Wood Perry, Jr.
1831-1915

Born in Boston, Perry left for London and Paris in 1852, eventually settling in Düsseldorf, where he studied for two years. In 1854, he returned to Paris and studied with Thomas Couture, spending another two years there before traveling to Rome. Upon his return to the United States in 1858, he established a studio in Philadelphia as a portrait painter. In the early 1860s, Perry developed an interest in landscape painting and traveled to California's Yosemite Valley with Albert Bierstadt in 1863. In 1886 Perry moved to New York, where he established a studio and turned his attention to genre scenes. He enjoyed a successful career throughout the remainder of his life, traveling and painting in both Europe and the United States. *JWT*

John Frederick Peto
1854-1907

Peto was born in Philadelphia and showed an early interest in drawing. In 1877 he enrolled at the Pennsylvania Academy of the Fine Arts. During his two years at the Academy, he was active in the Philadelphia art community, where he met and probably worked with Thomas Eakins and the still-life painter William Harnett. Having moved to the coast of New Jersey in 1889, he withdrew from artistic circles and stopped exhibiting in Philadelphia. In 1892, after Harnett's death, Peto acquired props from his studio; these would eventually appear in Peto's own work. *JWT*

Edward Henry Potthast
1857-1927

Potthast was the son of a cabinetmaker in Cincinnati, Ohio. As a youth, he worked as a lithographer and attended the McMicken School of Design. In 1882 he went abroad, and for three years studied in Antwerp and Munich. In 1887 he returned to Europe, this time to France. There he studied in various art colonies, including those at Barbizon and Grez and in the studio of Fernand Corman in Paris. During this period he was introduced to French Impressionism by the American painter Robert Vonnoh and the Irish artist Roderic O'Conor.

Potthast returned to Cincinnati in about 1893. Settling in New York in 1896, he worked for a time as a freelance lithographer before devoting his full time to painting. By 1908, he had a studio in the Gainsborough Building overlooking Central Park, a frequent subject of his paintings. In the summers, he painted on the New England coast. *NRS*

Maurice Prendergast
1858-1924

Prendergast moved with his family from Newfoundland, Canada, to Boston in the early 1860s. He went to work at age thirteen, spending much of his free time sketching. Having saved sufficient funds, he chose to study at the Académie Julian in Paris. He spent three years there, returning to Boston in 1895. Three years later, he traveled to Venice where he produced a series of watercolors that received rave reviews and gained the attention of Macbeth Galleries in New York. He returned to Paris in 1907 to seek new inspirations. His work became more forceful and vibrant upon his return, a change that was widely criticized. Prendergast exhibited at Macbeth Galleries as one of The Eight in 1908 and was involved in the organization of the 1913 Armory Show. In 1914 he moved to New York, where he continued to paint subjects similar to those of his earlier paintings; his work became increasingly abstract and less concerned with depicting the human figure. *JWT*

Robert Reid
1862-1929

Reid studied at the School of the Museum of Fine Arts, Boston, from 1880 until 1884. After a brief period at New York's Art Students League in 1885, he pursued his art education in Paris at the Académie Julian and spent his summers in Etaples on the Normandy coast. Returning to New York in 1889, Reid taught at the Art Students League and the Cooper Union and became active in mural decoration. A founding member in 1898 of the Ten American Painters, he exhibited with that group until 1919. In the late 1890s he turned to the large, decorative images of attractive young women dressed in exotic costumes or surrounded by flowers that would become his forte. *NRS*

Martin Andreas Reissner
1798-1862

Reissner was born in Germany, and when he was twenty-one years old moved to Riga, then part of Russia, where he may have received some of his early artistic training. He traveled throughout Europe, probably supporting himself by painting landscapes and theatrical backdrops. It appears that Reissner emigrated to the United States in 1848, as he exhibited a panorama of future president Zachary Taylor's military campaign in the Mexican War during that year. However, there are no official records of his living in the United States until 1849, when he exhibited at the American Art Union. He moved to Brooklyn in 1850, the only year he exhibited at the National Academy of Design. For the next ten years, Reissner traveled in America. He returned to Riga in 1861, where he spent the remainder of his life. *JWT*

John Singer Sargent
1856-1925

Born in Florence of expatriate American parents, Sargent received his initial art instruction in Italy. When he was eighteen years old, his family settled in Paris, where Sargent entered the studio of the fashionable portrait painter Emile Carolus-Duran. There, he developed the direct, economical approach, based on direct observation, that would characterize his style. His study of the paintings of Velázquez and Frans Hals on trips to Spain and Holland also influenced his development. In the late 1870s, Sargent's genre scenes and portraits of wealthy Parisians brought him success, but the scandal following the exhibition of his painting of the notorious Madame X (The Metropolitan Museum of Art, New York) at the Paris Salon of 1884 marked the end of his Parisian career. In 1886 he moved to London where he became one of the foremost portraitists of the time. Throughout his career, Sargent made several visits to America. While there, he painted wealthy New Yorkers and Bostonians. In 1890 he began work on mural decorations for the newly built Boston Public Library and devoted much of the next twenty-five years to the project. After 1907, Sargent virtually abandoned formal portraiture and turned to informal watercolor sketches of landscapes with figures. *NRS*

Francis Augustus Silva
1835-1886

Born in New York City, Silva first exhibited drawings at the age of thirteen. Following an apprenticeship to a sign painter, he established a studio at about age twenty-three. Three years later, in 1861 he joined the New York State Militia, serving through the end of the Civil War in 1865. His name reappeared in the New York City directories as a painter in 1867. The following year he exhibited at the National Academy of Design with the now-lost painting *Old Wreck at Newport*. This depiction of a shipwreck set the tone for the rest of his career. He lived in New York for the next twelve years until moving to New Jersey. However, he kept his studio in New York at the famous Tenth Street Studio Building until his death in 1886. *JWT*

Otto Stark
1859-1926

Born in Indianapolis, Indiana, Stark began his artistic career in the mid-1870s. He was first introduced to commercial woodcarving in Indianapolis, then to commercial lithography in Cincinnati, Ohio. His formal training in painting began at the University of Cincinnati, where he studied from 1877 to 1879. He moved to New York City later that year and supported himself as an illustrator, designer, and lithographer, while attending classes at the Art Students League. His teachers included William Merritt Chase, J. Carroll Beckwith, and Walter Shirlaw. He apparently also studied under Thomas Dewing. After six years in New York, Stark was financially able to move on, and in 1885 he traveled to Paris, selecting the Académie Julian for further study. He also worked for about a year in the *atelier* of Fernand Cormon. In France, Stark absorbed many influences; his palette ranged from dark to bright, and the techniques he used, which included Impressionism, were as varied as the spectrum of his subjects. Returning to New York in 1888, he worked in commercial art and exhibited the products of his French experience at the National Academy of Design. In 1890 he moved to Philadelphia, then back to Cincinnati, where he found work as a designer for a lithography company. He returned to Indianapolis in 1893 and opened a studio the following year on East Market Street,

where he taught classes in oil and watercolor. Until about 1890 Stark's subjects were primarily landscapes, portraits, and narrative and figure paintings. During the decade his palette lightened and became more impressionistic. In 1899 he was appointed supervisor of art at the Emmerich Manual Training High School in Indianapolis, and in 1902 he became an instructor at the John Herron Art Institute. Following his retirement in 1919, Stark lived and painted in the woods near Leland, Michigan, with excursions to Florida and Indiana. Although he continued to exhibit until the end of his life, Stark's later work lacked the vision of the years during and soon after his return from Europe. He died of a stroke at his daughter's home in Indianapolis in 1926. *AT*

Julius LeBlane Stewart
1855-1919

Julius LeBlane Stewart was born in Philadelphia, son of the prodigious collector William Hood Stewart (1820-1897). At the end of the Civil War the Stewarts moved to Paris, where the family continued to be supported by prosperous Cuban sugar plantations. The elder Stewart collected the contemporary works of Alma-Tadema, Baudry, Boldini, Bonnat, Corot, Fortuny, Gérôme, Madrazo, Meissonier, Rico, Stevens, Troyon, and Zamacoïfs, and the younger Stewart was acquainted from an early age with many of these artists. J. L. Stewart described himself as a student of, Zamacoïfs, Gérôme, and Madrazo, and since the first of these painters died in 1871 when Julius was only sixteen, his art training apparently began at an early age. He entered Gérôme's atelier on 15 May 1873 and the latter's biographer Fanny Hering noted that he was one of the master's *beloved pupils*. Stewart accompanied the Frenchman to Egypt for a few months in 1874. In the mid-1870s he moved into a studio adjacent to Madrazo's on the Rue Copernic. The influence of the popular Spaniard immediately became evident in Stewart's work such as the ambitious A. J. Drexel family portrait, *After the Wedding* (Drexel University, Philadelphia) of 1880. Stewart made his debut at the Paris Salon in 1878 with two paintings, and for the next three decades exhibited continuously there as well as throughout Europe and America. His *Portrait of a Lady*

(unlocated) in the 1883 Salon was called by the *Art Amateur* "the most sensational American picture of all." He continued his success at the Salon in 1884 with *Five O'clock Tea* (private collection, Philadelphia). The artist's greatest success at the Salon was *The Hunt Ball* (Essex Club, Newark) of 1885, the acclaim for which occasioned a pendent, *The Hunt Supper* (Buffalo Club) of 1889. In the early 1880s the critics noted that Stewart was one of the principal proponents of a hybrid form of painting, a cross between portraiture and genre invariably depicting friends from the world of high society or theater in their milieus. While this form is indebted in part to the drawing-room genre compositions of his friend Jean Béraud as well as to works of contemporaries such as Albert Aubert and J.J.J. Tissot, Stewart brought it to the public attention at the Salon with large-scale works like *The Hunt Ball*. Much of the fascination of these works derived from the identification of the sitters. His female subjects included Lillie Langtry, Sarah Bernhardt, Christine Nilsson, Laure Hayman, the countess of Essex, the vicomtesse de Gouv d'Arcy, Baronne Rothschild, Baronne Benoist-Mechin, Baronne Bethmann, and Madame Bischoffsheim. Portraits of men included duc de Morny, Baron Nathaniel de Rothschild, vicomte de Jange, Anthony J. Drexel, and James Gordon Bennett. Bennett, the greatest international sportsman of the era, was Stewart's most loyal patron, and was portrayed in two of the artists's most accomplished works, *On the Banks of the Seine at Bougival* (1885, Manoogian Collection), and *The Yacht Namouna in Venetian Waters* (1890, Wadsworth Atheneum). In the late 1890s Stewart painted nudes in landscapes and views of Venice, as well as society portraits. Like Béraud, he also began to paint religious subjects in contemporary costume in the early 1900s. Stewart's reputation was in eclipse until the mid-1970s, when it was revived by inclusion in a series of exhibitions (Dayton 1976, Detroit 1983). *DDT*

Arthur Fitzwilliam Tait
1819-1905

Born in Liverpool, England, Tait learned to draw while employed at Thomas Agnew's print shop in Manchester, where he also acquired skills in the new technology of lithography. In 1848 he turned to painting in oils, producing a few canvases of horses as well as other sporting scenes. In 1848 Tait emigrated to America and soon established himself as a leading painter of animals and of hunting, fishing, and camping subjects. He became best known, however, for the prints made after his works and issued by Curler & Ives, Louis Prang, and other lithographers. *NRS*

John Henry Twachtman
1853-1902

Twachtman was born in Cincinnati, Ohio, in 1853 and studied art at the Ohio Mechanics Institute and the McMicken School before enrolling at the Art Academy of Cincinnati. It was there that he met Frank Duveneck, whom he would eventually join in Europe. The two artists enrolled at the Royal Academy of Fine Arts in Munich, and they traveled together often. In Venice in 1880, they met James McNeill Whistler, who greatly influenced Twachtman's later work. Twachtman studied at the Académie Julian in Paris from 1883 to 1885 and moved back to the United States in 1886, settling in Connecticut. During the 1890s, he joined The Ten American Painters. Although Twachtman was never fully appreciated by the public, he was greatly admired by fellow artists and some critics. *JWT*

Irving Ramsey Wiles
1861-1948

Irving Ramsey Wiles was born in Utica, New York and raised in New York City. He considered a career as a violinist before becoming an artist. By age 17, he was studying art with his father and at age 18, he exhibited at the National Academy of Design. From 1879- 1881, he studied at the Art Students League under James Carroll Beckwith and William Merritt Chase. Chase and Wiles became lasting friends. Before his death, Chase asked Wiles to complete his unfinished portrait commissions. In 1882, Wiles attended the Académie Julian in Paris, studying under Gustave Boulanger and Jules-Joseph Lefebrve. He returned to New York City in 1884. Wiles divided his time between painting portraits, illustrating for *Century, Harper's,* and *Scribner's* magazines, and teaching in his studio and at his father's art school during the summer months. After his election to the National Academy of Design in 1897, Wiles was able to spend more time on his portraits. He eventually moved his summer classes and settled in Peconic, Long Island. He remained there until his death at age 87. *VK-H*

George Wright
n.d.

Very little is known about George Wright except that he was active around 1880 to 1900. In 1888, he exhibited at the National Academy of Design in New York. At this time, he was listed as a resident of Philadelphia, Pennsylvania. *VK-H*

Production Notes
Editor: Nicolai Cikovsky, Jr.
Technical Editors: Vivian Kung-Haga, Katherine Lawrence, Sally Kee and Neil O'Brien
Photography: Courtesy of the Manoogian Collection
Printing and Color Separations: J.W. Moore Printing Co., Inc.
Paper: Zanders Mega Gloss 100# Cover and 100# Text from International Paper